THE MASTER GUIDE TO DRAWING ANIME
AMAZING GIRLS

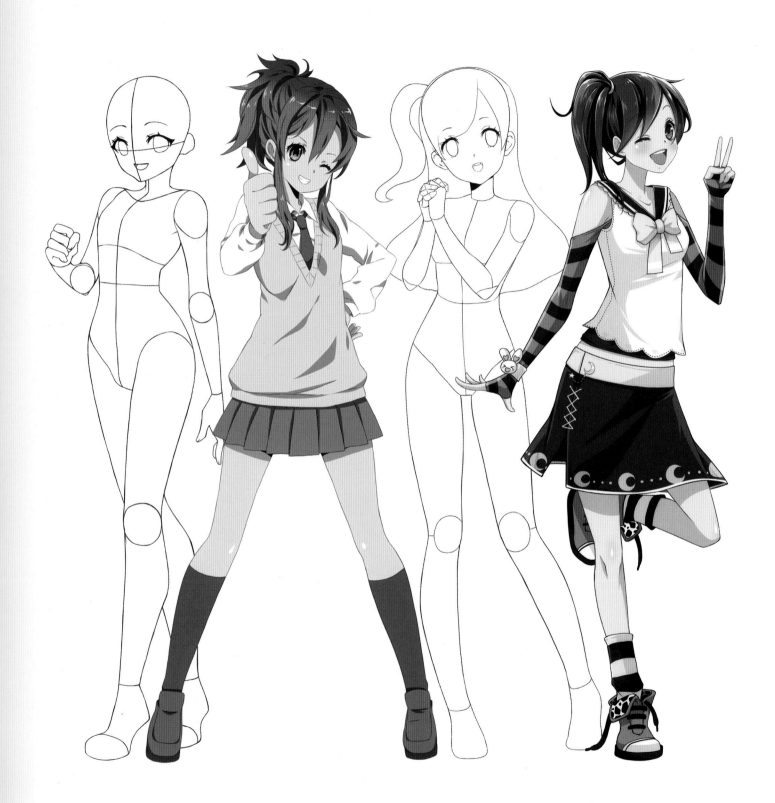

DRAWING WITH *Christopher Hart*

THE MASTER GUIDE TO DRAWING ANIME

AMAZING GIRLS

How to Draw Essential Character Types from Simple Templates

 Get Creative 6

DRAWING WITH Christopher Hart

An imprint of **Get Creative 6**
104 West 27th Street, New York, NY 10001
sixthandspringbooks.com

Editor
LAURA COOKE

Art Director
IRENE LEDWITH

Editorial Assistant
JACOB SEIFERT

Design
JULIE GRANT

Production
J. ARTHUR MEDIA

Contributing Artists
INMA R.
ERO-PINKU
TABBY KINK
KAGURA
AKANE
HAIYUN
AYAME
AYASAL

Vice President
TRISHA MALCOLM

Publisher
CAROLINE KILMER

Production Manager
DAVID JOINNIDES

President
ART JOINNIDES

Chairman
JAY STEIN

Library of Congress Cataloging-in-Publication Data
Names: Hart, Christopher, 1957- author.
Title: Amazing girls : how to draw essential character types
from simple templates / by Christopher Hart.
Description: First edition. | New York : Get Creative 6, 2017.
| Series: The master guide to drawing anime | Includes index.
Identifiers: LCCN 2017022886 | ISBN 9781942021841
(paperback)
Subjects: LCSH: Girls in art. | Comic books, strips, etc.--
Japan--Technique. | Cartooning--Technique. | Drawing--
Technique. | BISAC: ART / Techniques / Cartooning. | ART /
Techniques / Drawing.
Classification: LCC NC1764.8.G57 H34 2017 | DDC
741.5/952--dc23

2017022886

MANUFACTURED IN CHINA

14

First Edition

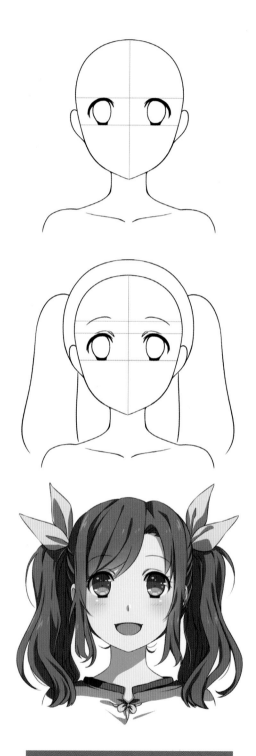

My thanks go to Art Joinnides, Carrie Kilmer, Joan Krellenstein, Laura Cooke, and Irene Ledwith at Soho Publishing for making great books. And of course, to you, my readers!

www.youtube.com/chrishartbooks

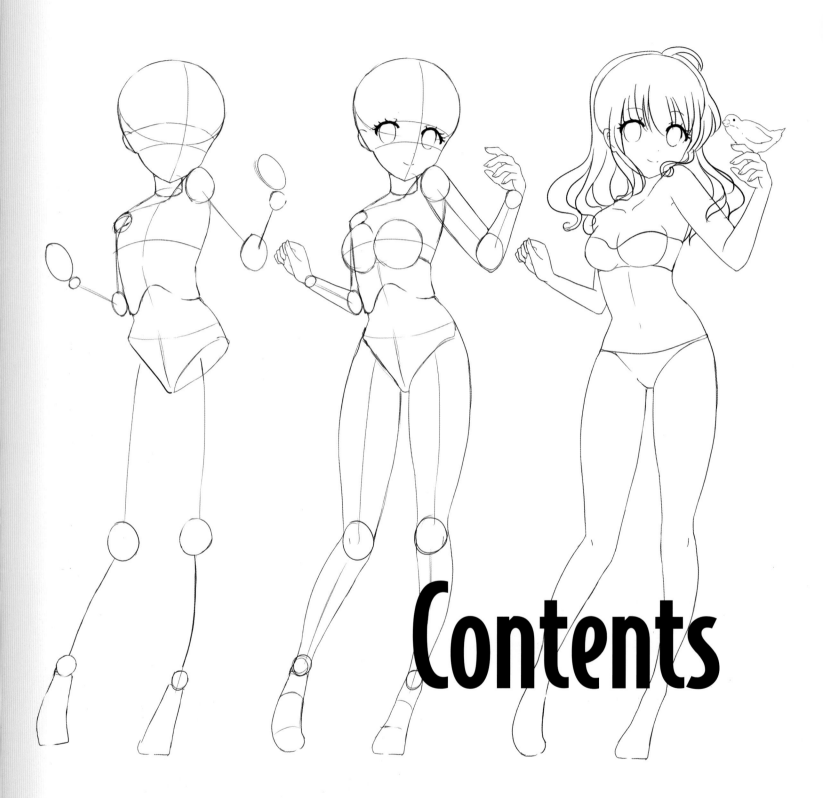

Contents

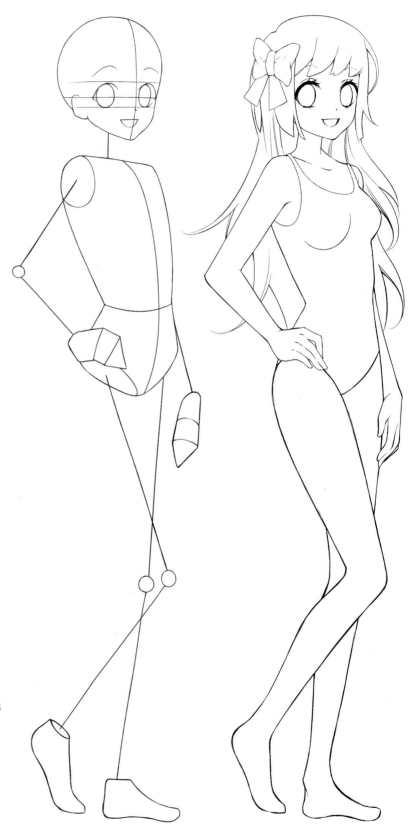

Introduction

Girls are the fan favorites of anime.

There are many popular types of anime girls, each with a unique personality. And now, you can learn how to draw them all! With this book, you'll learn the tricks to drawing a character's facial features and expressions as well as the proportions of the body, poses, and even hairstyles and outfits. Aspiring artists will find the guided instructions easy to follow and fun to use.

This book is based on simple templates; therefore, once you can draw one character, you can draw them all. There are the famous Japanese *Dere* character types, which are fan favorites. If you aren't yet familiar with these essential schoolgirl types, this book will get you up to speed. We also cover funny characters, beautiful characters, dramatic characters, pop culture characters, and many more.

You will also find an abundance of step-by-step examples. We'll start off drawing the head and body, and then we'll dive into the specific character types. Next, we'll work our way through popular genres such as comedy and romance. Finally, we introduce the concepts for drawing backgrounds to help set the scene for your characters.

As one anime fan to another, I'm glad to share this adventure with you as we draw these amazing characters together! ∎

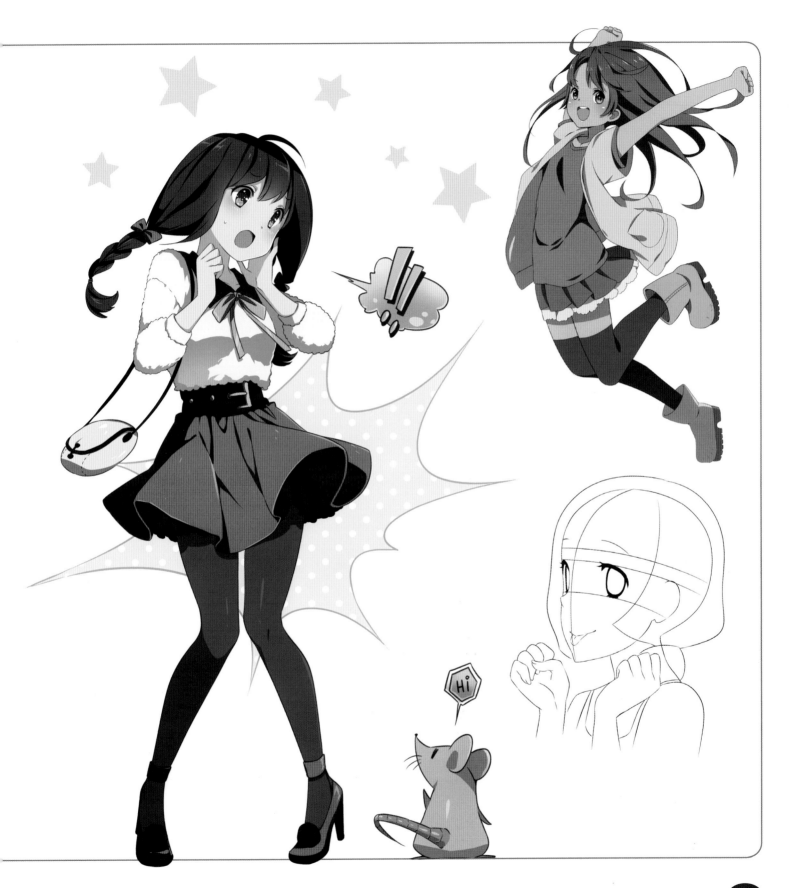

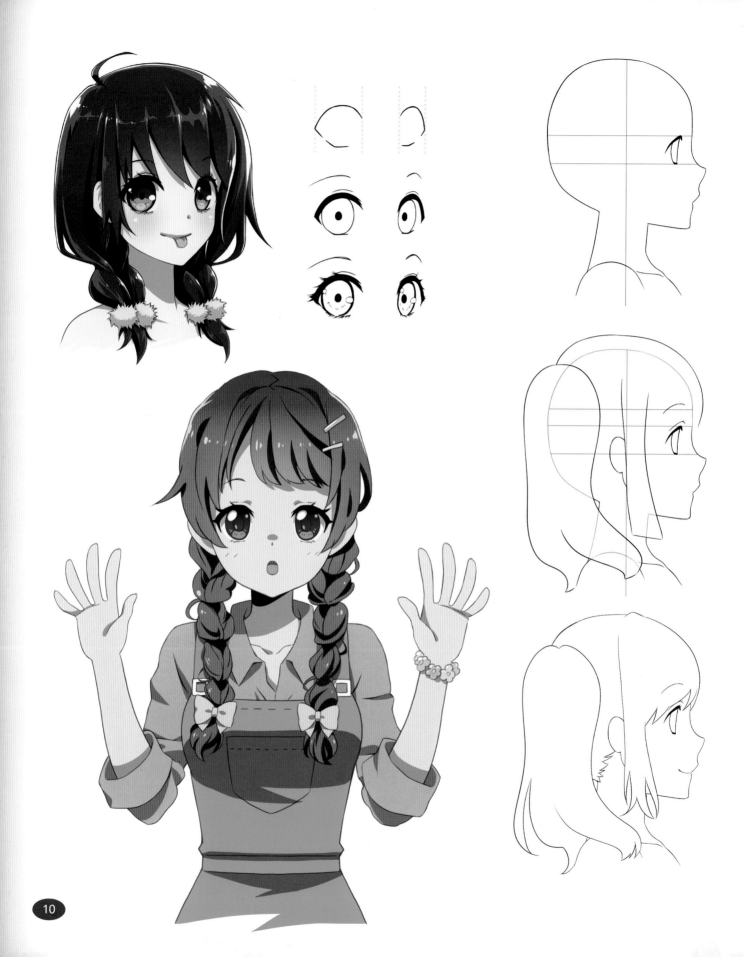

The Female Head

Let's draw amazing girl characters.

The way to draw beautiful characters is to start with the basic head shape. Yes, gorgeous anime eyes are essential, but they only look good on a well-proportioned face. We'll learn how to properly draw those proportions using basic head templates, then move on to drawing hairstyles and expressions. Now, let's start drawing some amazing girl characters! ∎

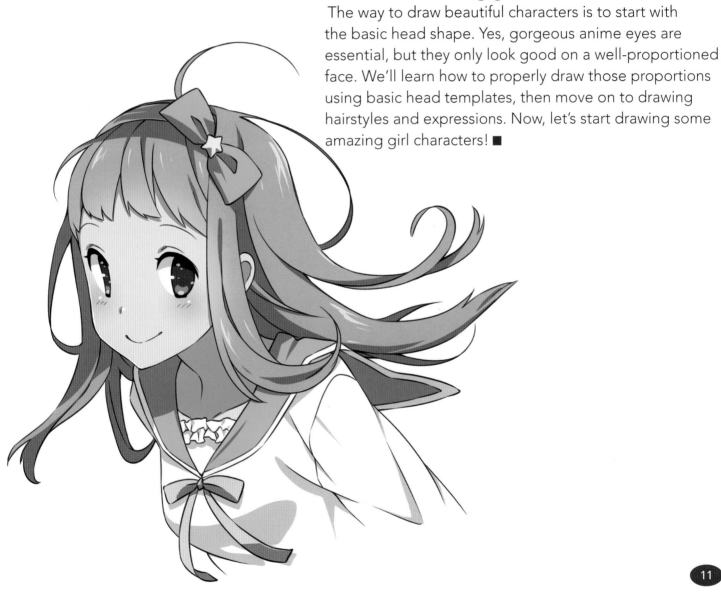

Basic Proportions

Let's begin by sketching the foundation of the head. This will give you a useful template (basic shape) for drawing many types of girl characters. Below, you'll see some proportions to keep in mind when creating your own characters. If your proportions end up slightly different from those in this book, don't worry. There are always variations. It's the general look we're after.

THE FRONT VIEW

The proportions are indicated by the blue guidelines. The vertical line is called the *Center Line*. The horizontal line under the eyes is called the *Eye Line*.

BASIC HEAD TEMPLATE: FRONT VIEW

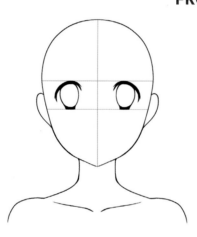

Two eye lines are drawn to keep the eyes in place.

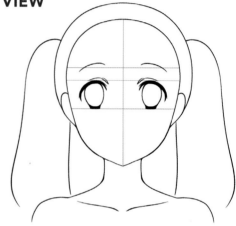

Another blue guideline is drawn just a notch above the eyes to indicate the eyebrows.

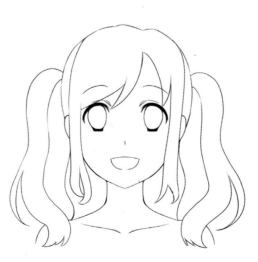

The head appears well proportioned and symmetrical.

The hair falls over the forehead to create bangs.

THE SIDE VIEW

The eye is thin in the side view, but it's the same height as it is in the front view. The more the character turns her head away from us, the viewer, the more slender it will appear.

BASIC HEAD TEMPLATE: SIDE VIEW

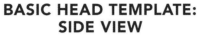

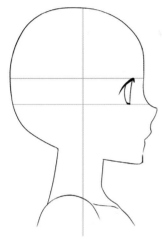

Bracket the eyes between the two horizontal guidelines.

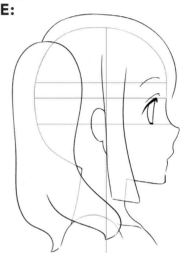

The curve of the eyebrow mirrors the curve of the upper eyelid.

The vertical guideline goes down the middle of the head. This is where you draw the ear.

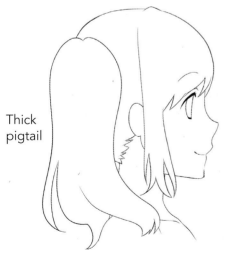

The bangs fall over the eyebrows.

Thick pigtail

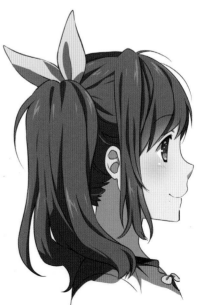

Curved bridge of nose

Indicating light and dark areas in the hair adds depth.

Drawing Practice—Heads

Now let's practice what we've covered by doing some character sketching. The facial features—eyes, hairstyles, and expressions—will come together to produce unique and appealing characters. You can sketch loosely or use as much detail as you like.

LEFT ANGLE

Leave a lot of room between guidelines that run above and below the eyes.

Remember this axiom: Big eyes are for cute characters.

Hair isn't static. Let it flow freely.

RIGHT ANGLE

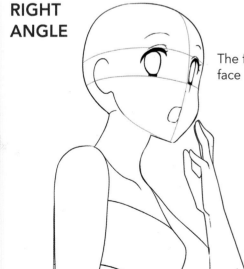

The front of the face is quite curvy.

The amount of space behind her ear is minimized in the ¾ angle. The full size of the head is only apparent in profile.

Attractive Eyes

When drawing eyes, knowing what to draw first helps. Start by drawing the upper and lower eyelids to frame the eyes. With that in place, draw the eyeballs and finish with the details: the eyelashes, eyebrows, and creases of the eyelids.

EYE TEMPLATE: THE FRONT VIEW

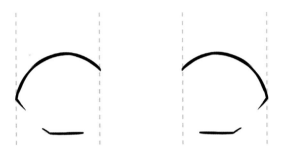

STEP 1
The upper eyelids droop at the ends.
The lower eyelids are flatter.

STEP 2
Draw small pupils dead center in the eye and indicate a faint fold above the upper eyelids.

STEP 3
Add random streaks to the iris and a few shines. Draw feathering on the eyelashes.

The color of the eyeball is dark on top but fades at the bottom.

EYE TEMPLATE: ¾ VIEW

You're probably aware that the far eye, in the ¾ view, appears smaller than the near eye. (Or, if you weren't, you are now!) To achieve this look, draw the far eye narrower.

STEP 1
The eyelids start off at different sizes in the ¾ view.

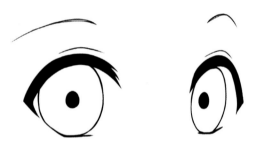

STEP 2
The near eye is circular, while the far eye is an oval. The left pupil is dead center, while the right pupil is off center.

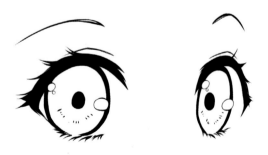

STEP 3
Draw the far eyebrow shorter and more arched than the closer one.

Wide, open eyes create an upbeat look.

EYE TEMPLATE: SIDE VIEW

Here's where some people find drawing eyes to be tricky. But this diagram should clear things up for you.

STEP 1
In the side view, the eyelids converge to form a point.

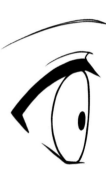

STEP 2
The pupil (black dot) is drawn toward the front of the iris.

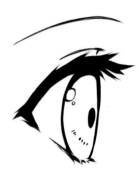

STEP 3
The eyelashes extend beyond the eyeball.

It's time to add the anime-style shine to the eye. A small shine in the upper left side is all it takes, but you can add more.

Popular Hairstyles—The Basics

A stylish haircut can help to establish a character's type. For example, cute characters are often drawn with short- or medium-length hair, whereas beautiful characters are frequently given long hair. A hairstyle becomes part of a character's identity.

THREE BASIC LENGTHS

The length affects the shape of the hair. Generally, longer hair is straighter because gravity pulls it down. This was Newton's most important discovery, but it got lost in the story about the cookie he invented.

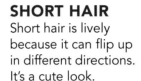

SHORT HAIR
Short hair is lively because it can flip up in different directions. It's a cute look.

LONG HAIR
Long hair can fall midway down the back or further. This length features silky, flowing lines that can be used to connote gentleness.

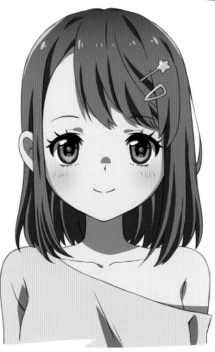

MEDIUM LENGTH
Of course, you can create your own variations, but the standard for medium-length hair is the shoulders. This cut creates a friendly look.

SUPER-LONG HAIR

Without a doubt, this is the star hairstyle of anime characters. The graceful look enhances a character's beauty. It's drawn with several long strands in front of the ears.

Establish the character—the underlying form—before you start to draw the hair.

The hanging strands of hair begin above the ears.

Sketch the general flow of the hair without details.

Having established the basic look, add a few energetic flips to the top.

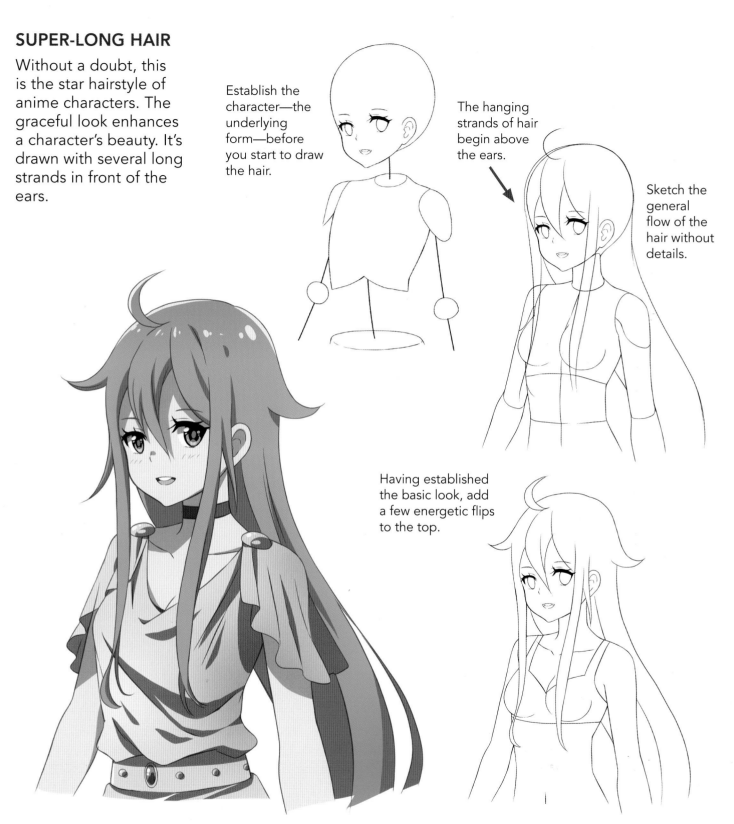

A little motion gives the hair a flowing appearance.

BRAIDS

There are two questions that have puzzled artists since man painted on cave walls. The first is, "How do you get a wooly mammoth to pose for you?" And the second is, "How do you draw braids?" I'll answer the second question first, and we can circle back to paleontology

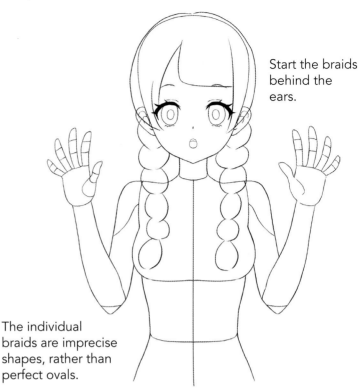

Start the braids behind the ears.

The individual braids are imprecise shapes, rather than perfect ovals.

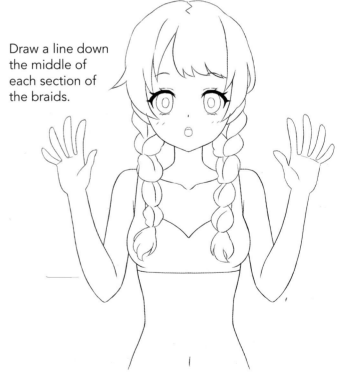

Draw a line down the middle of each section of the braids.

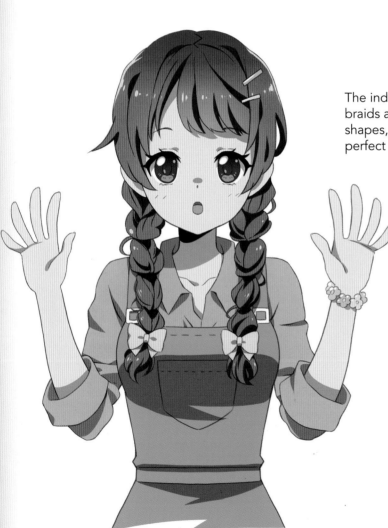

Braids flop over the front of the shoulders. It doesn't make sense to create eye-catching braids only to toss them behind the character's back.

RINGLETS

Ringlets are a fun change of pace from ordinary hairstyles. The swirling lines capture the viewer's eye. They also say something about a character—that she enjoys spending half a day primping her hair!

Draw several thick rows of ringlets. No details at this stage of the drawing.

The bangs are cut straight across the forehead.

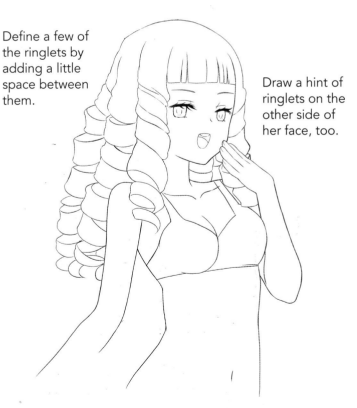

Define a few of the ringlets by adding a little space between them.

Draw a hint of ringlets on the other side of her face, too.

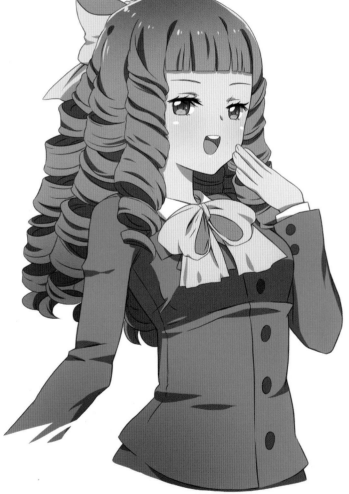

Most people could use more self-esteem. She on the other hand, could use less.

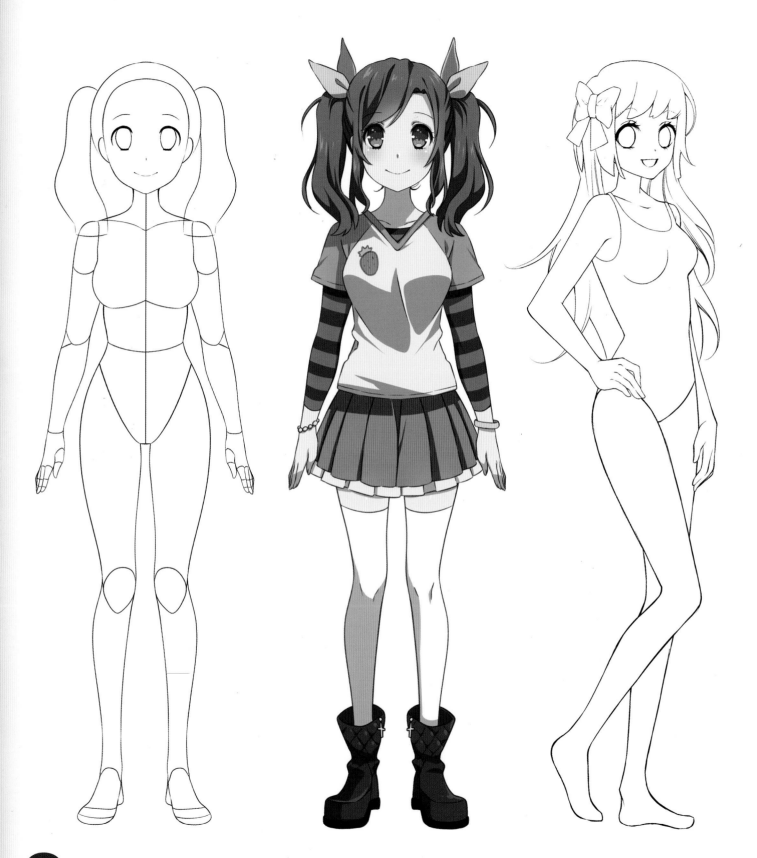

The Basic Female Body

The attractive anime figure is easy to draw once you know the key concepts. We'll start with a versatile body type that can be used for many different characters. Our focus will be on the proportions, contours, and poses. You don't need to memorize this. Simply observe how the concepts work, and allow them to sink in as you draw. ■

Basic Proportions

The major proportions of the body are indicated by the blue guidelines below. Whether you draw the character small or large, the relative proportions remain the same.

Anime artists begin by drawing the body in segments.

Leave space between the arms and the body.

Smooth out the segments to create a flowing, sleek figure.

Lightly indicate the knee joints.

FRONT BODY TEMPLATE

The ideal character is 6 ½ "heads" tall.

The elbows appear at the same level as the waistline. (You'll find that this is a particularly useful proportion!)

The fingers are almost halfway down the thigh—but not quite.

The feet are approximately shoulder-width apart.

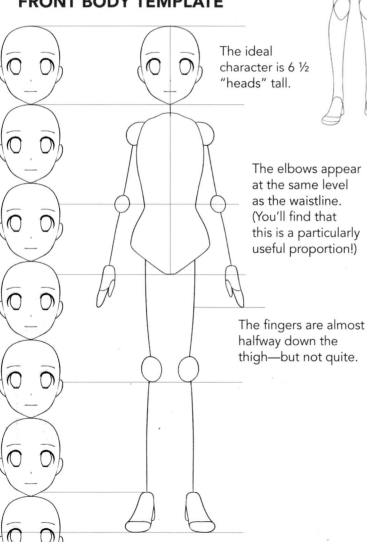

The steps have paid off. The final drawing is an appealing anime girl in a fun outfit.

SIDE BODY TEMPLATE

By using the same proportions each time, the character will remain consistent. A frequent question from beginners is how to draw a character so that it looks the same at every angle. This is how.

With the proportions in place, the torso is divided into three basic sections: ribcage, midsection, and hips.

In the side view, the character has the same proportions as she did in the front view: 6 ½ heads tall. So right off the bat, we're being consistent.

The elbow lines up with the bottom of the ribcage.

The fingers reach almost to mid-thigh.

Smooth out the figure so that it no longer appears to be assembled.

As you can tell, it's much easier to draw step-by-step than to wing it.

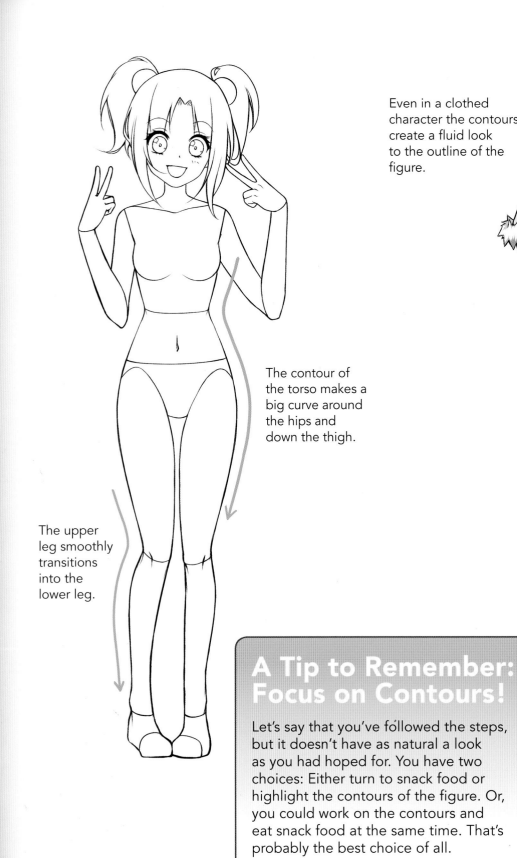

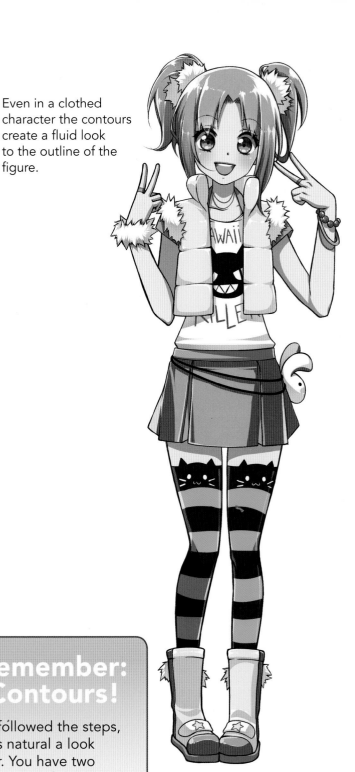

Even in a clothed character the contours create a fluid look to the outline of the figure.

The contour of the torso makes a big curve around the hips and down the thigh.

The upper leg smoothly transitions into the lower leg.

A Tip to Remember: Focus on Contours!

Let's say that you've followed the steps, but it doesn't have as natural a look as you had hoped for. You have two choices: Either turn to snack food or highlight the contours of the figure. Or, you could work on the contours and eat snack food at the same time. That's probably the best choice of all.

Bodies Come in All Shapes and Sizes

They say that bodies come in all shapes and sizes. Oh really? Have you ever seen a person in the shape of a rhomboid? Still there are a variety of female figures you can use to create unique characters. Here are four basic body types.

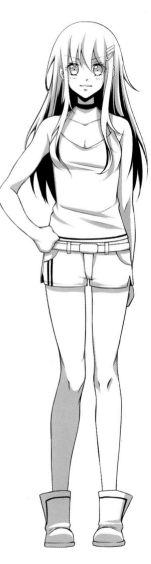

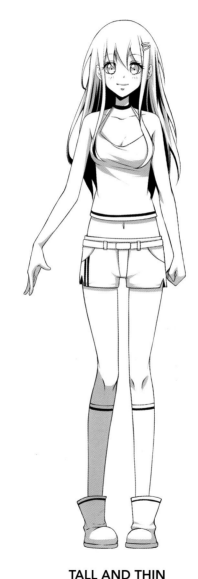

CLASSIC
This versatile character type has well-balanced proportions.

FULL FIGURE
This character's proportions are the same as those of the classic character, but with a slightly fuller figure.

ATHLETIC
She has a strong build and a confident pose. She's tall, and her arm muscles have some definition.

TALL AND THIN
Tall, slender characters are drawn with longer arms and legs. This girl also has a slightly elongated torso and narrower hips.

Mannerisms

You can express an attitude simply by adjusting the way your character stands. Here are some examples of popular anime mannerisms of schoolgirls that can be expressed in simple standing poses.

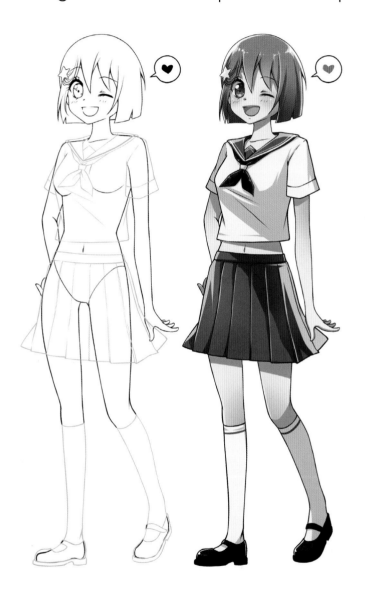

OUTGOING

She has a relaxed, unguarded manner and stands with her arms away from her body.

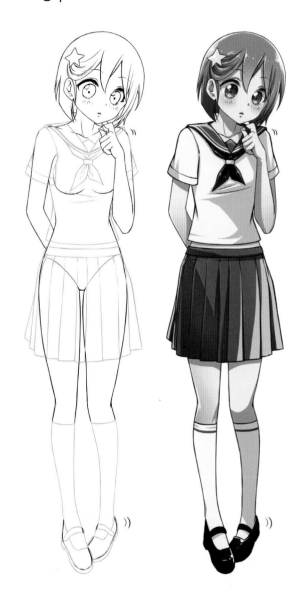

INNOCENT

This pose mimics the stance of a much younger character. Notice the foot position.

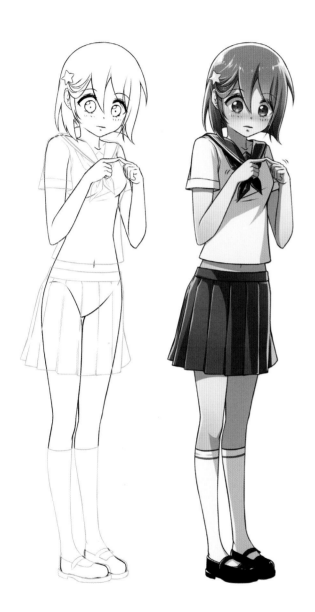

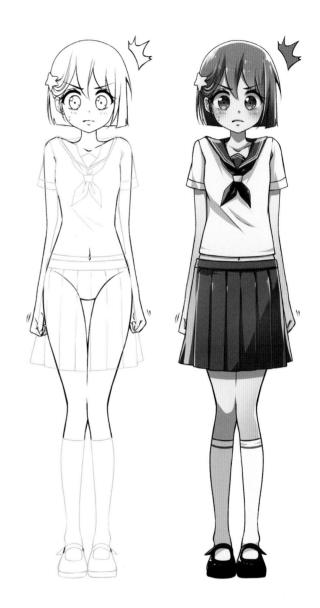

ANXIOUS

She braces herself for the worst. Draw her
elbows close to the body, and bring her hands
together. Note the lifted shoulders.

UPSET

She becomes stiff as a board. Her legs
are pressed together, which creates a pose
with total symmetry.

Drawing Bodies—Practice

Front and side views are great for learning the proportions. But bodies are meant to move, so let's draw some dynamic poses.

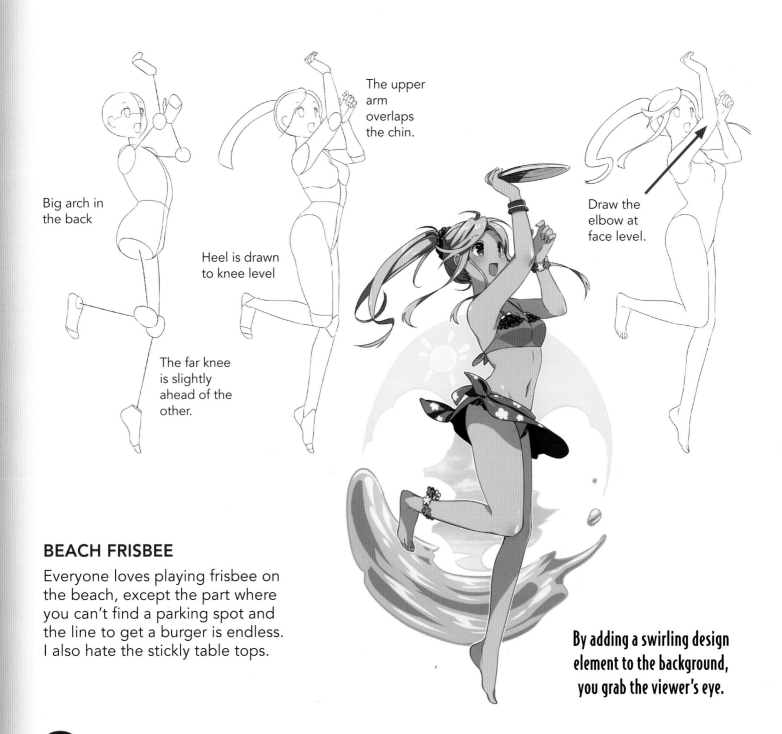

Big arch in the back

The upper arm overlaps the chin.

Heel is drawn to knee level

The far knee is slightly ahead of the other.

Draw the elbow at face level.

BEACH FRISBEE

Everyone loves playing frisbee on the beach, except the part where you can't find a parking spot and the line to get a burger is endless. I also hate the stickly table tops.

By adding a swirling design element to the background, you grab the viewer's eye.

POKING FUN

Why is it that every time you get a bad haircut, this character shows up? Spill something on your sweater? She's there. Note her finger-pointing gesture, and big smile.

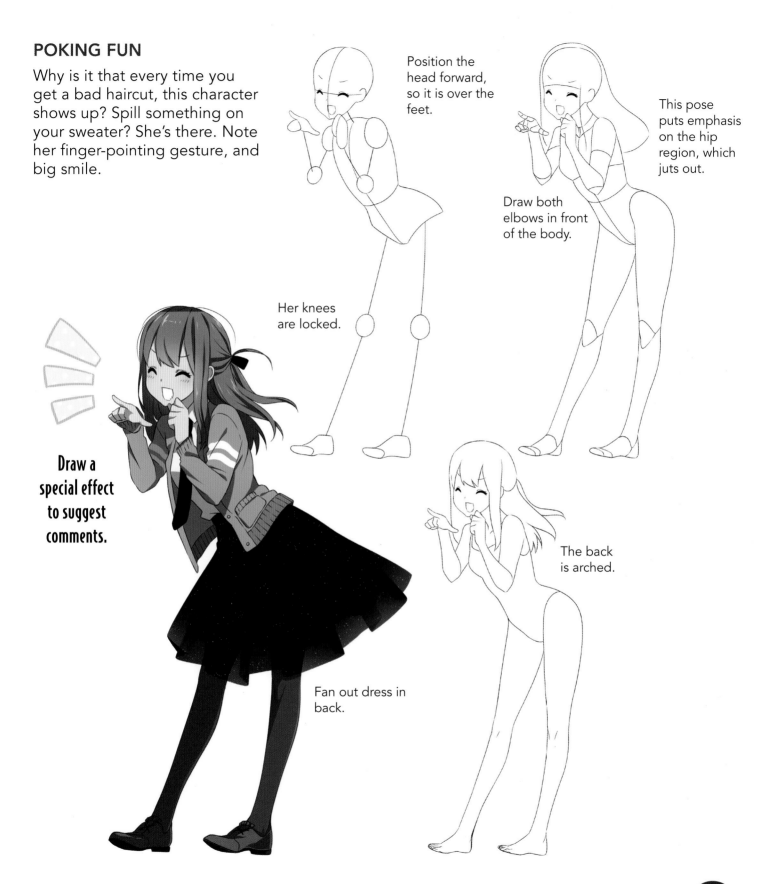

Position the head forward, so it is over the feet.

Her knees are locked.

Draw a special effect to suggest comments.

Fan out dress in back.

This pose puts emphasis on the hip region, which juts out.

Draw both elbows in front of the body.

The back is arched.

FREAKING OUT

When a cute character loses it, she does so in a funny way. The key is to draw a shocked expression with a cute look that I call "shock and awwwww." You know, in some countries, you can get arrested for making a pun that bad.

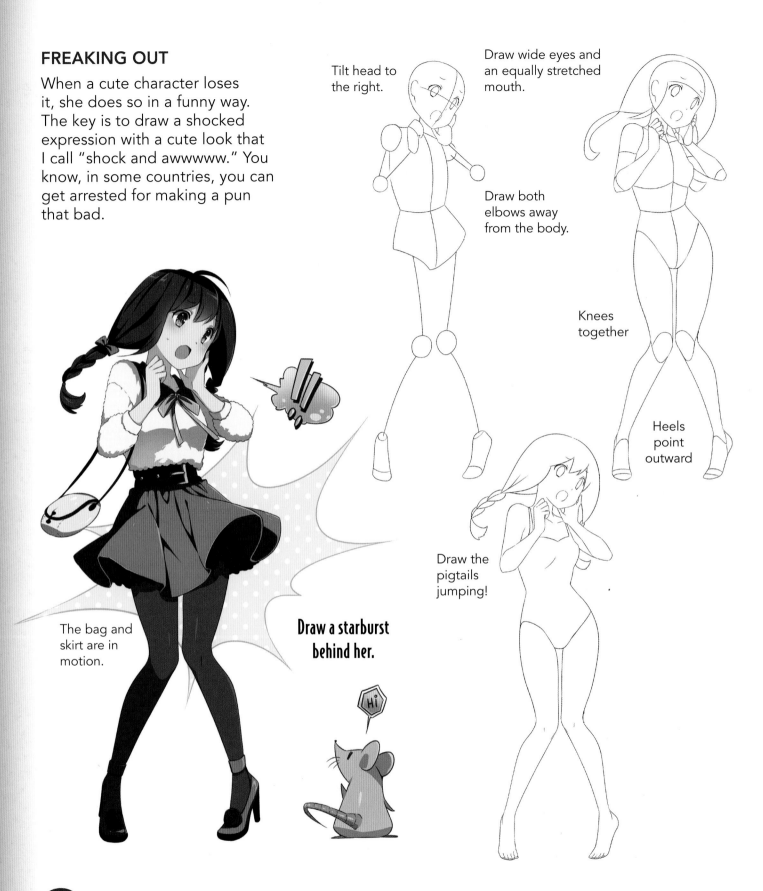

Tilt head to the right.

Draw wide eyes and an equally stretched mouth.

Draw both elbows away from the body.

Knees together

Heels point outward

The bag and skirt are in motion.

Draw a starburst behind her.

Draw the pigtails jumping!

HI

ALWAYS LATE!

An urgent expression grabs the viewer's attention because we can all relate. Who among us hasn't, at one time or another, been late for class or had to outrun a river of molten lava? Pretty much everyone.

Even when she's running like crazy, she's on her cell phone. This is a case of art imitating life.

Be bold! Extend the near leg way out in front.

Draw the toes pointed up.

As one leg goes forward, the elbow on the same side goes back.

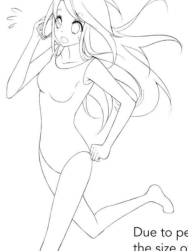

Due to perspective, the size of the back foot is reduced.

Draw a few "sound" lines emanating from the phone.

Her loose fitting top falls just below the hips.

FUN LOVING

Here's an important tip: Always try to match the gesture to the facial expression. This spontaneous pose goes with the smile and wink.

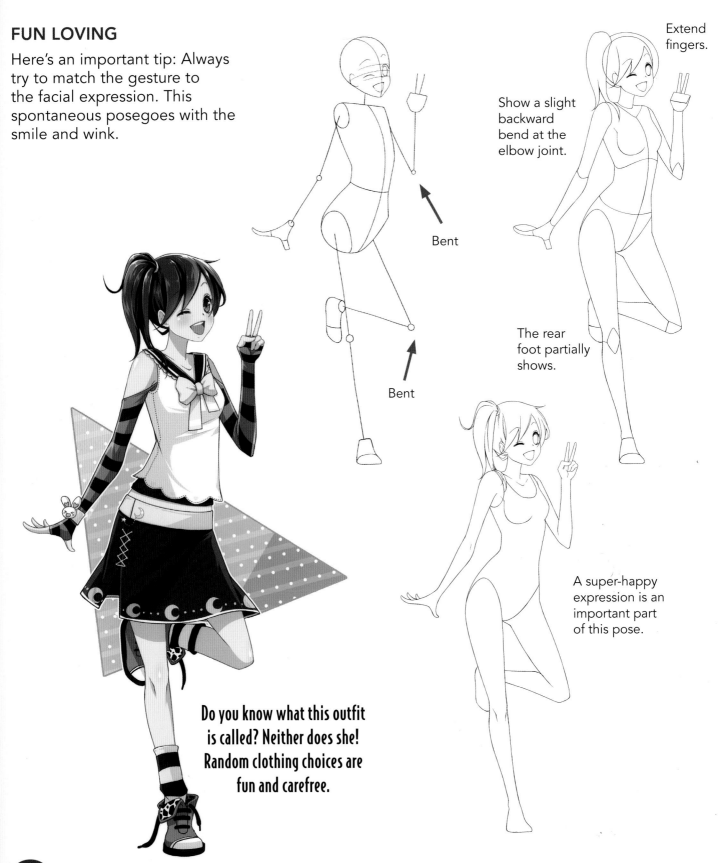

Extend fingers.

Show a slight backward bend at the elbow joint.

Bent

The rear foot partially shows.

Bent

A super-happy expression is an important part of this pose.

Do you know what this outfit is called? Neither does she! Random clothing choices are fun and carefree.

STYLISH

It's easy to suggest a stylish look. Simply draw one leg bent and resting on the ball of the foot. Then draw the hand (the one on the same side as the bent leg), on the hip. Style is as much an attitude as it is a choice of clothing.

Cup the hand over the hip, which indicates the hip is round.

Draw the knees together.

Show a small portion of the far leg.

The far arm almost disappears behind the torso.

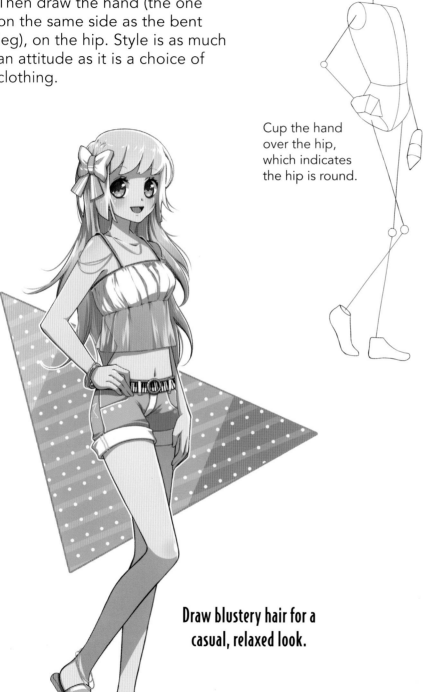

Draw blustery hair for a casual, relaxed look.

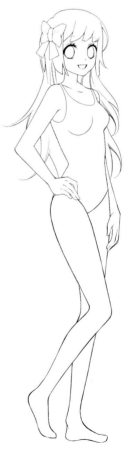

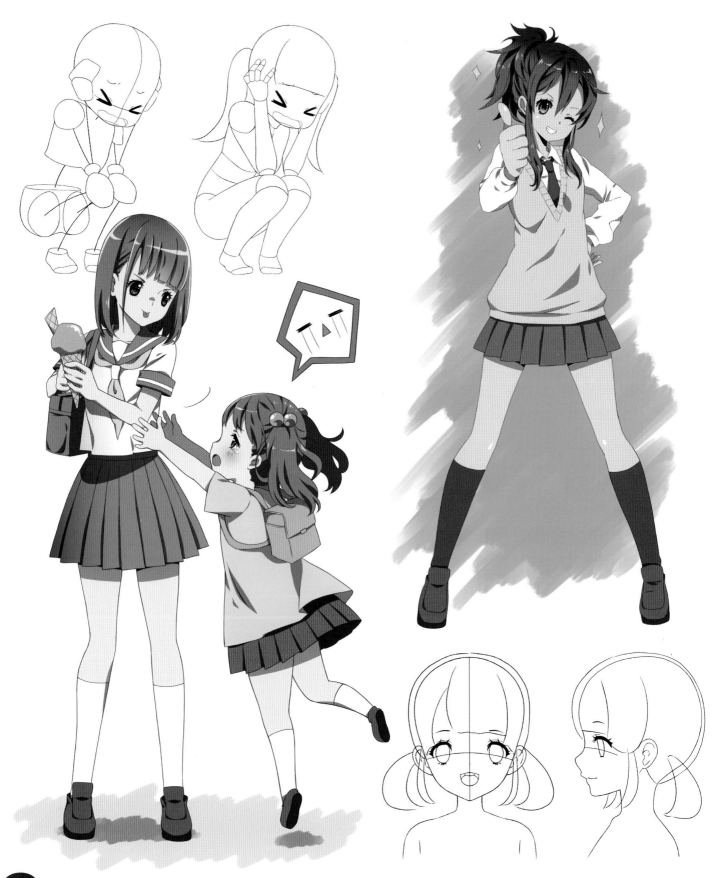

Young Characters

Younger teenagers, ages 12-14, are a popular subgroup of characters in anime. They entertain audiences with their funny antics and unpredictable behavior. They can switch from one emotion to another with lightning speed. This chapter introduces easy-to-draw templates for the head and body of these fun personalities, along with a selection of fun character types. ■

The Youthful Head—Key Points

Younger teens are typically drawn with an exaggerated forehead and an undersized chin. These proportions are used universally for young characters. Also, the head is rounder for younger teens. This gives them a charming look.

HEAD TEMPLATE: FRONT VIEW

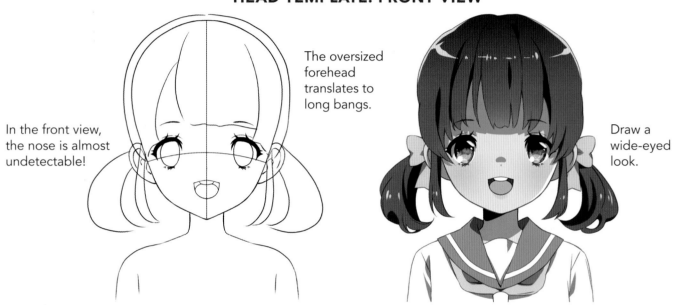

In the front view, the nose is almost undetectable!

The oversized forehead translates to long bangs.

Draw a wide-eyed look.

HEAD TEMPLATE: SIDE VIEW

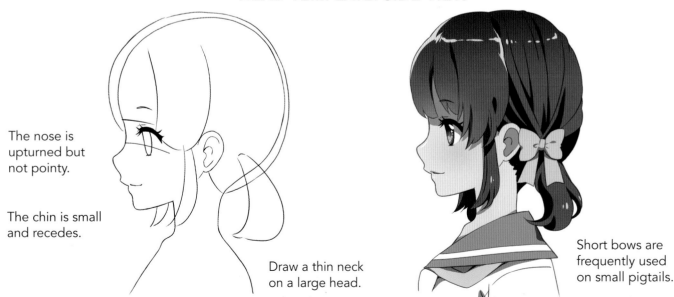

The nose is upturned but not pointy.

The chin is small and recedes.

Draw a thin neck on a large head.

Short bows are frequently used on small pigtails.

The Youthful Body—Key Points

Young characters aren't simply short versions of older characters. Young characters have slightly shorter limbs, relative to the size of the body. Their hips are narrower. And their muscles are not quite developed yet.

BODY TEMPLATE: SIDE VIEW

The torso and hips don't bend quite so much on younger characters.

The midsection is slightly shortened.

BODY TEMPLATE: FRONT VIEW

Draw a narrow neck.

Small shoulders

Small hands and feet

This basic template can be used to create many different personalities in a similar age range.

The waist doesn't get very narrow on youngsters.

Drawing the elbows and knees slightly inward creates a childlike look.

Famous Young Character Types

Just as there are cliques of characters in high school, middle school characters have their stars too. People sometimes assume that young characters have quiet emotions, but the opposite is true. They have energetic, fun personalities

SPITEFUL

Spiteful characters are in every school. Older sisters have all the power. That's bad news if you're the little sister of one of them!

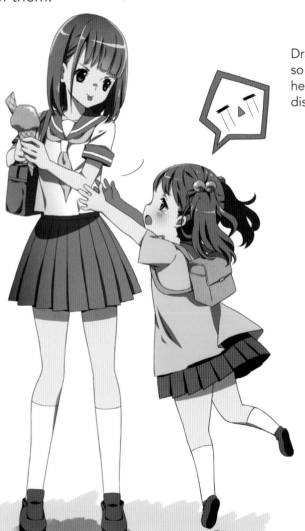

She withdraws her arms across her body.

The mean girl makes use of any advantage at her disposal, like height.

The younger sister's arms and legs are extended.

Draw the head tilted so she looks down at her little sister with disrespect.

Her shoulder overlaps her chin.

Sometimes little sisters grow up to be taller than their big sisters. That's when things really get interesting.

Exaggerate the size of the hand.

Draw the head with a significant downward tilt, which emphasizes the winking expression.

The lower hand is partially hidden behind the hips.

When the head tilts forward, the ponytail appears to rise in back.

The feet are drawn wide apart, for a self-assured stance.

The midsection thins out.

SUNNY DISPOSITION

No matter what trouble occurs, this character will find a silver lining. A rainy day? No problem! It's cozier indoors. Lost your purse? The best things in life are free! Sentenced to solitary confinement? Who doesn't need some "alone" time?

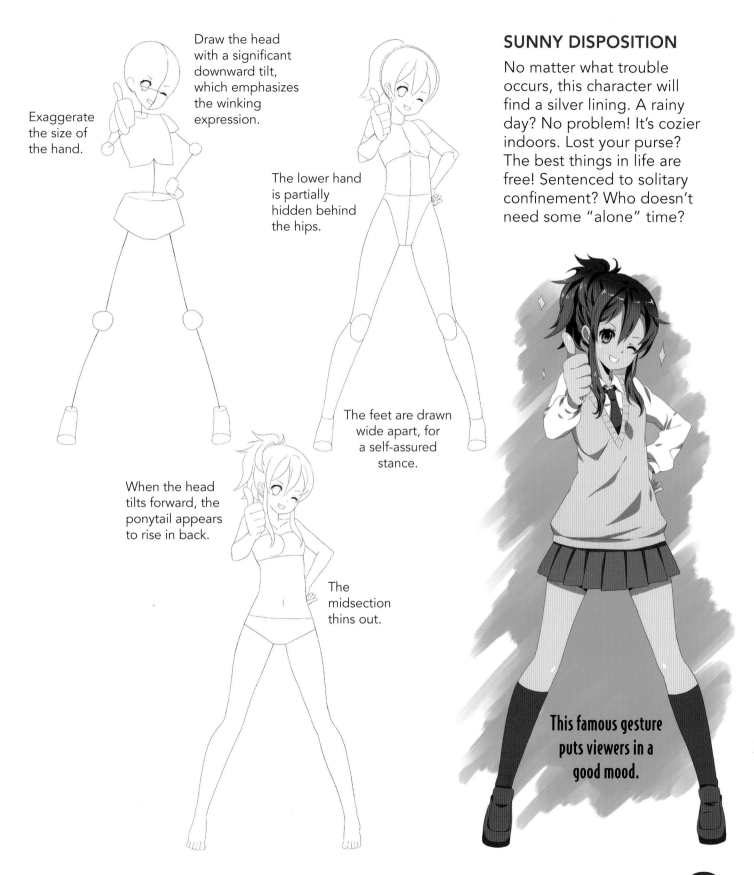

This famous gesture puts viewers in a good mood.

LONELY GIRL

Her mom is busy at work. Her dog is at the kennel. And her teddy bear just ran away from home. It makes you want to draw some new characters, just to cheer her up. Notice the withdrawn stance, as if her friends have abandoned her.

Draw a symmetrical pose.

Flowing hair overlaps some of her face, for a spontaneous effect.

Draw even hips.

The hands are drawn at the level of the sternum (the hollow just below the breast bone).

Draw the elbows at the level of the waistline.

The thighs are wide at the low end of the hips.

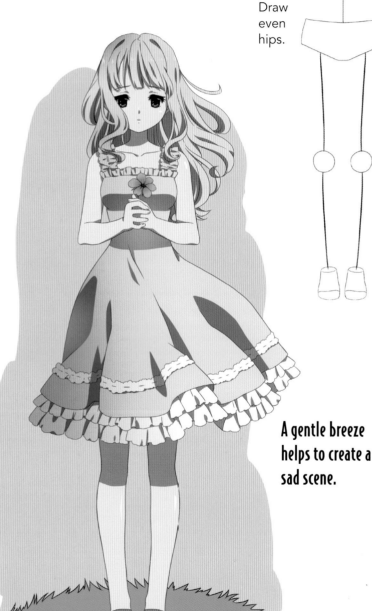

A gentle breeze helps to create a sad scene.

Draw interlaced fingers. If that seems complicated, then draw one hand over the other.

By drawing the feet close together, you create a meek look.

FUNNY KID

If you're an aspiring anime artist, you'll want to draw the ever-popular funny kid. I was a funny kid in school. All the students laughed at my jokes. The teachers found it less amusing. Funny kids are adorable, but can also be annoying. Just ask their pets.

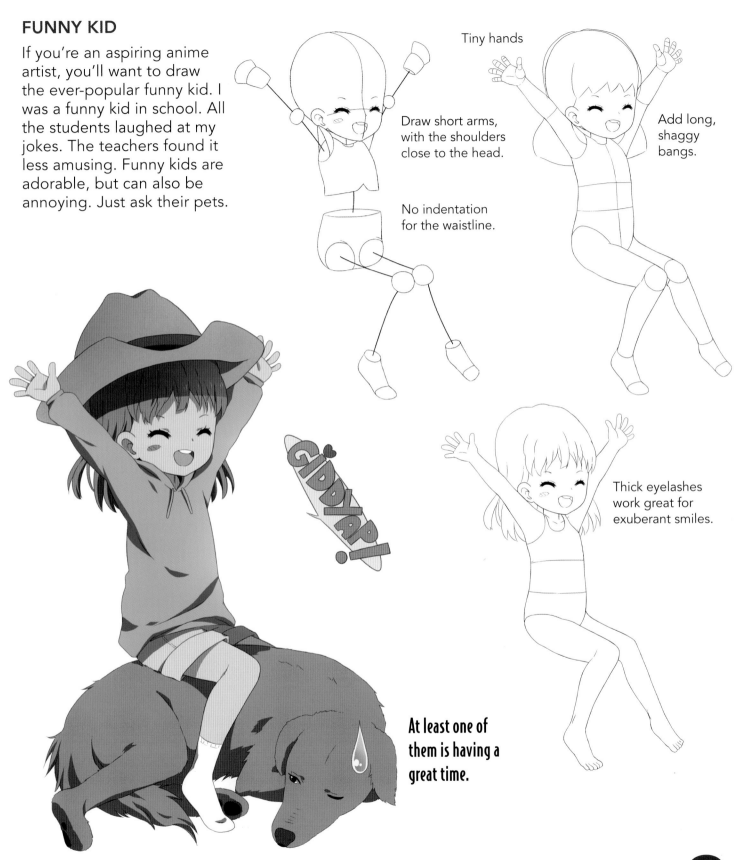

Draw short arms, with the shoulders close to the head.

No indentation for the waistline.

Tiny hands

Add long, shaggy bangs.

Thick eyelashes work great for exuberant smiles.

GIDDYAP!

At least one of them is having a great time.

ANXIOUS

Surprised is when you see a UFO just outside of your window. *Shocked* is when you've been beamed aboard. Shock is an instant reaction, and the entire body gets involved. There's almost no transition. The character goes from zero to sixty in a split second.

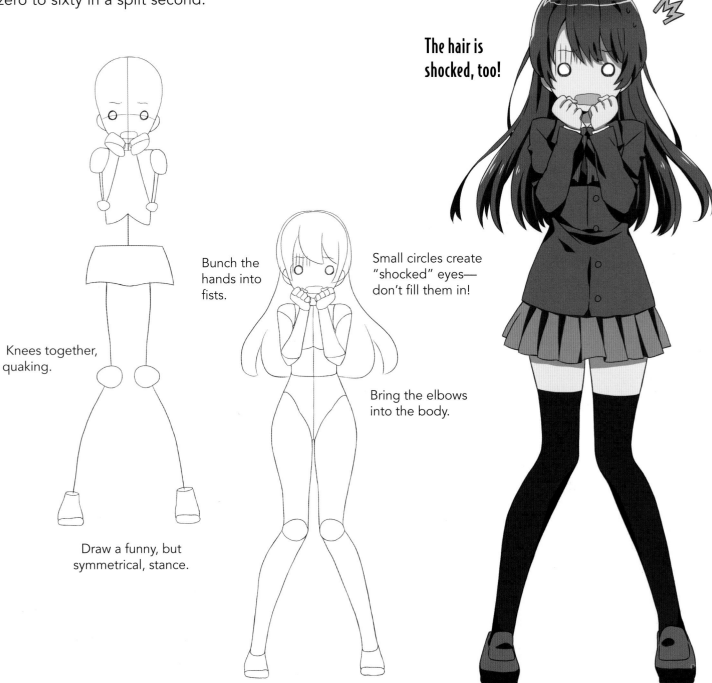

The hair is shocked, too!

Knees together, quaking.

Draw a funny, but symmetrical, stance.

Bunch the hands into fists.

Small circles create "shocked" eyes— don't fill them in!

Bring the elbows into the body.

This is a symmetrical pose: both elbows together, both knees together, and both feet together.

Draw the hips lower than the knees.

Draw the mouth opened wide.

The body leans forward. You can use a slanted, straight line as a guide.

SCARED

No matter how unflappable you might be, everyone has experienced fear. Maybe you fear spiders or something worse, like a visit from your cousins. The ones who think the capital of the United States is the Mall of America.

Since we're going for broke, let's draw a super-frightened expression.

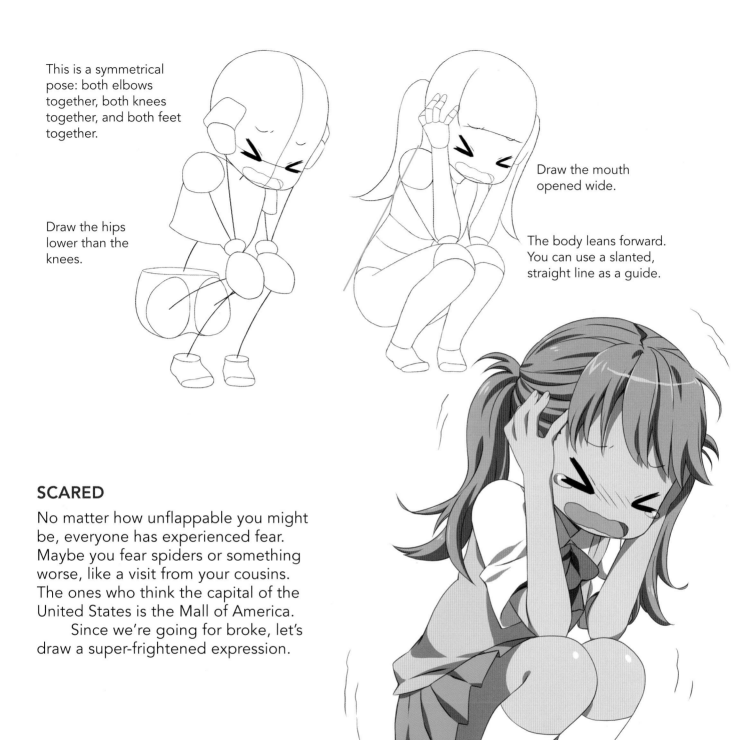

Looks like she's either seen a ghost or her grades.

SOOO MAD!

Can an angry expression get laughs? Yes, if you follow a simple technique. Instead of letting out an explosion of fury, bottle it up. Get your character to fume, but don't let her explode. Look how tightly wrapped this character is.

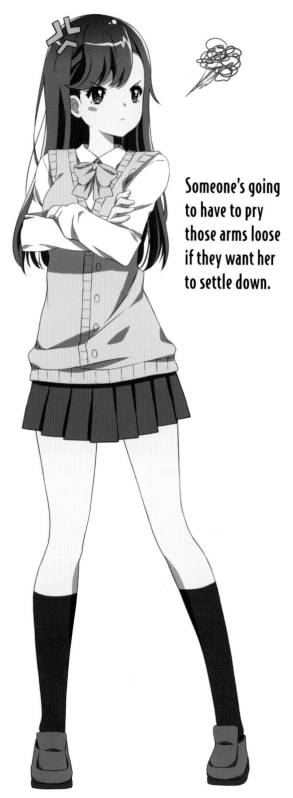

Someone's going to have to pry those arms loose if they want her to settle down.

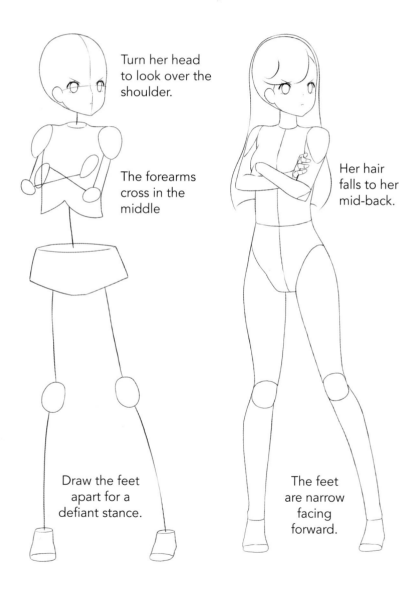

Turn her head to look over the shoulder.

The forearms cross in the middle

Draw the feet apart for a defiant stance.

Her hair falls to her mid-back.

The feet are narrow facing forward.

CRAZY IN LOVE

Crazy love. Is there another type? It's awfully nice to have someone who really loves you, but if you see someone looking at you with this expression, you'd better duck. This is a take-no-prisoners type of love. Her expression practically turns chibi. He must be the boy of her dreams.

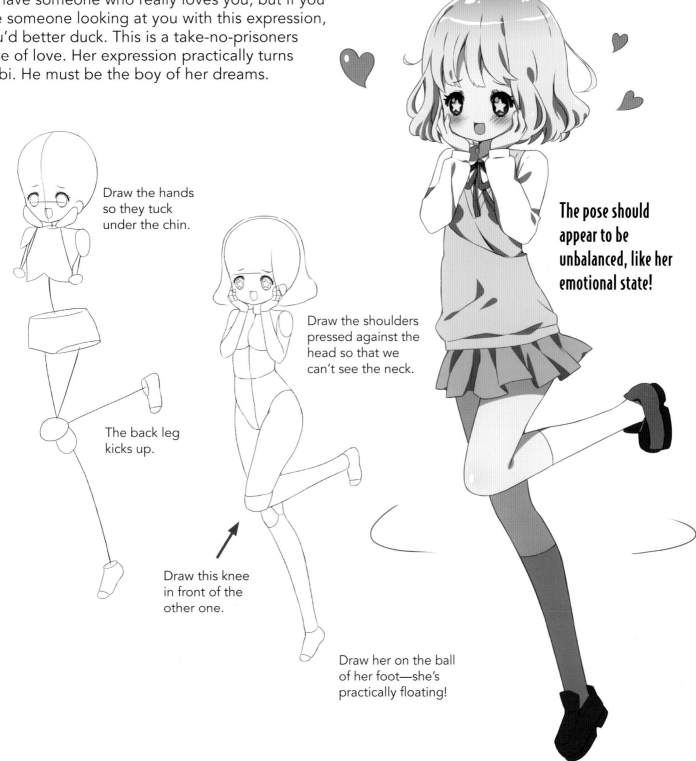

Draw the hands so they tuck under the chin.

The back leg kicks up.

Draw this knee in front of the other one.

Draw the shoulders pressed against the head so that we can't see the neck.

Draw her on the ball of her foot—she's practically floating!

The pose should appear to be unbalanced, like her emotional state!

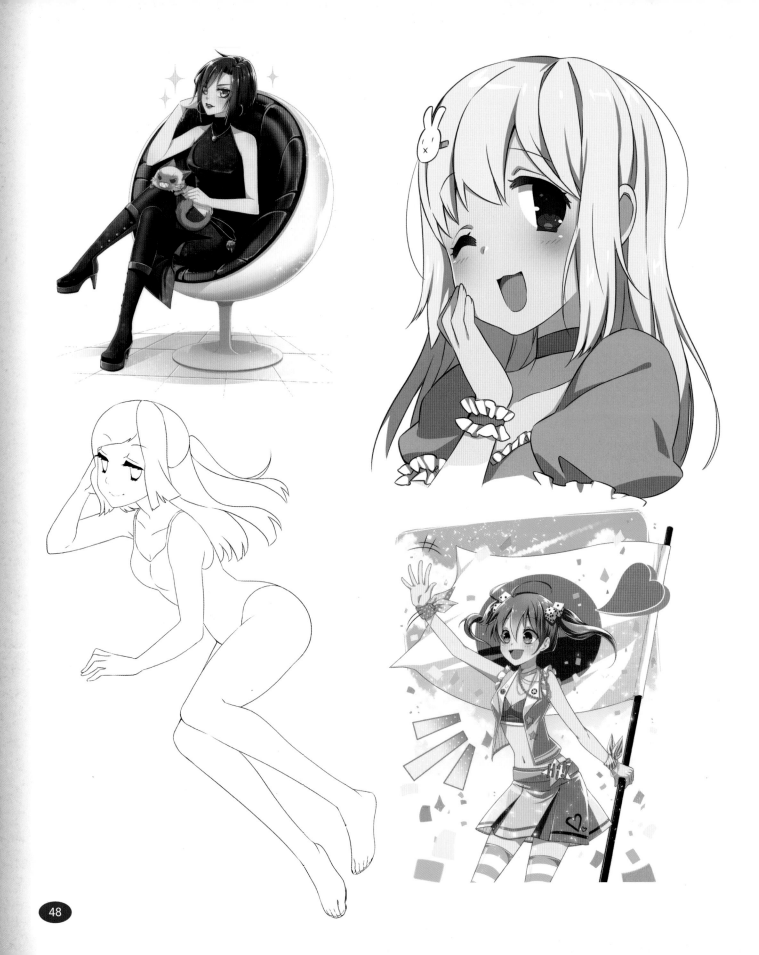

The *Deres:*
Seven Essential Girl Personalities

This is the chapter all anime fans have been waiting for. Here, you'll learn how to draw the character types that star in your favorite anime: the *Deres*. There's the *Tsundere*, the *Yandere*, the *Undere*, and other popular types. Each has an established personality in anime. Some are funny, some are jealous, and some are conceited. When you add boys to the mix, the sparks fly. I'll explain each one as we go along.

We'll also explore essential characters that go beyond the Deres. These crowd-pleasers drive stories and make entertaining cast members. With so many character types to work with, your anime characters will never be boring. ■

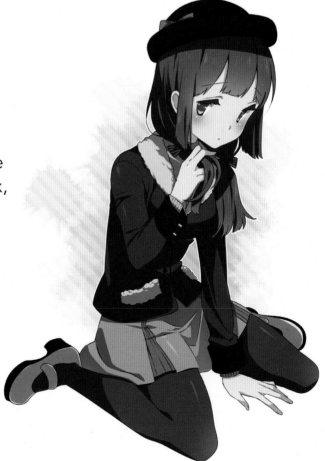

Dere Character Templates

Use these basic templates for drawing each type of Dere personality. You can also customize them to create your own Dere Characters. Now, let's create some comedic dysfunction!

TSUNDERE

The *Tsundre* is the most popular of the Dere girls. Her type acts chilly and antagonistic to the boy she secretly likes, completely confusing him. It's not the best strategy to win a guy's affection. However, she'll occasionally let her guard down and reveal her feelings. But the next moment, she'll return to verbally tormenting him.

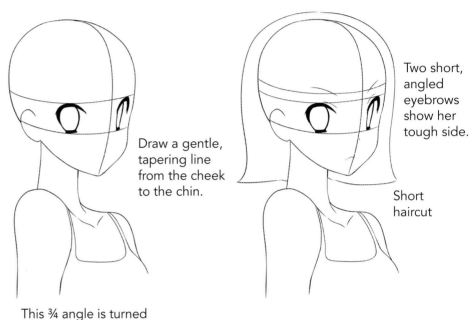

Draw a gentle, tapering line from the cheek to the chin.

Two short, angled eyebrows show her tough side.

Short haircut

This ¾ angle is turned pretty far to the right, so you'll have to draw her far eye very slender.

Orange hair for a fiery personality

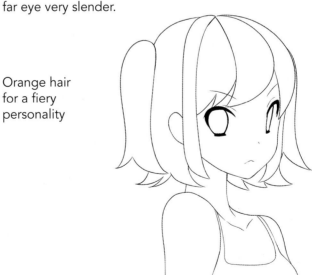

Define the hair with some floppy layering.

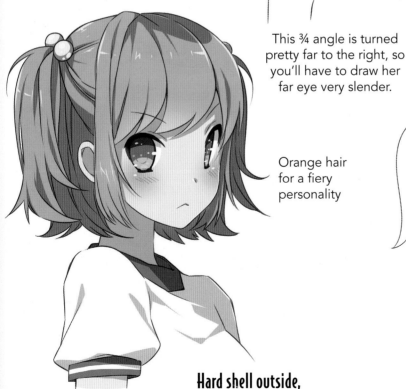

Hard shell outside, soft on the inside

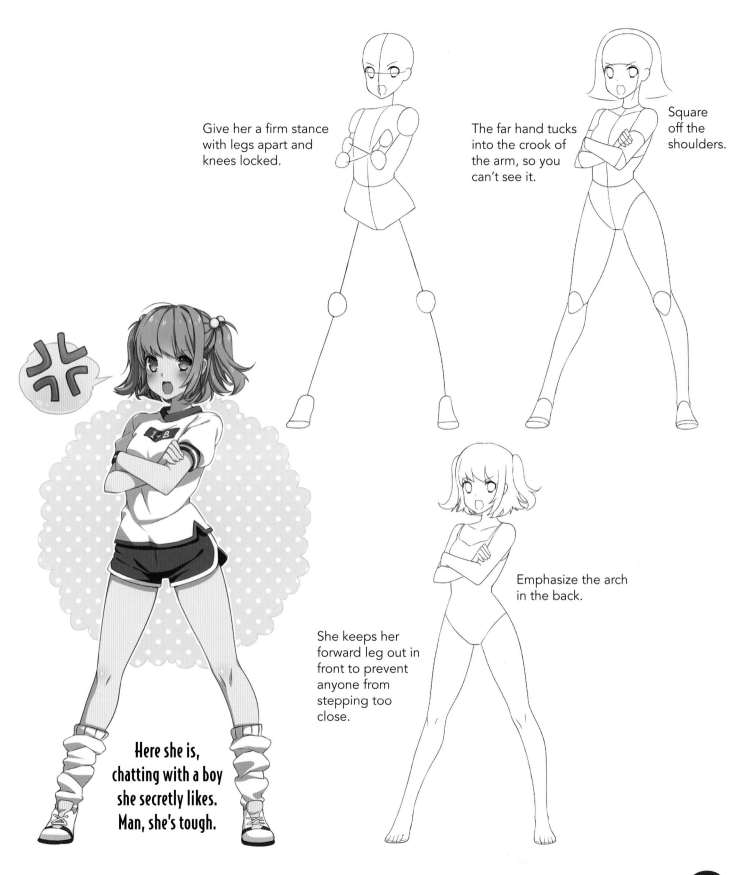

Give her a firm stance with legs apart and knees locked.

The far hand tucks into the crook of the arm, so you can't see it.

Square off the shoulders.

Emphasize the arch in the back.

She keeps her forward leg out in front to prevent anyone from stepping too close.

Here she is, chatting with a boy she secretly likes. Man, she's tough.

KUUDERE

The *Kuudere* has made an art form of repressing her true feelings. Therefore, it's almost impossible for her to open up to anyone. She hides her feelings so well that even she has a hard time finding them.

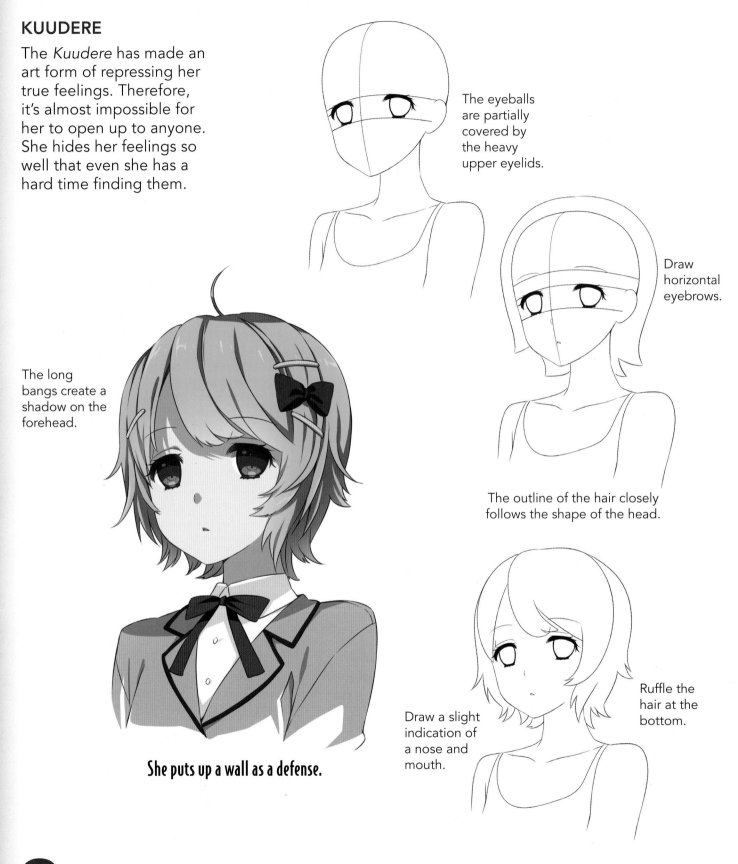

The eyeballs are partially covered by the heavy upper eyelids.

Draw horizontal eyebrows.

The long bangs create a shadow on the forehead.

The outline of the hair closely follows the shape of the head.

Draw a slight indication of a nose and mouth.

Ruffle the hair at the bottom.

She puts up a wall as a defense.

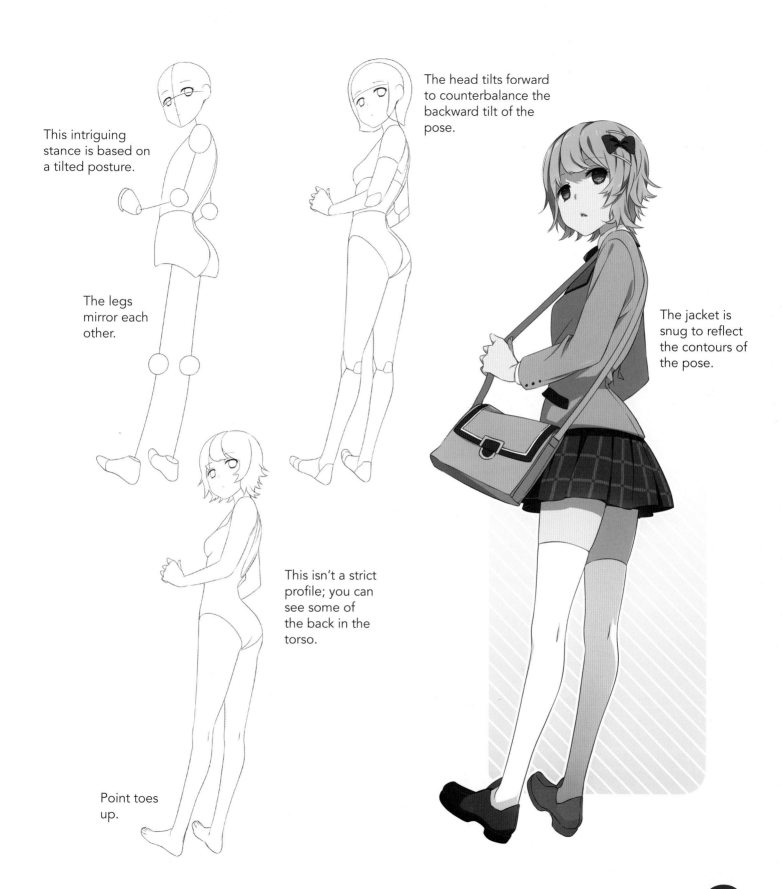

This intriguing stance is based on a tilted posture.

The legs mirror each other.

The head tilts forward to counterbalance the backward tilt of the pose.

The jacket is snug to reflect the contours of the pose.

This isn't a strict profile; you can see some of the back in the torso.

Point toes up.

DANDERE

The *Dandere* is sweet but meek. She'll open up to you, but you've got to invest a lot of time and energy getting to know her. And yet, the Dandere can emerge to become a magnetic character in the same way that a butterfly emerges from its cocoon.

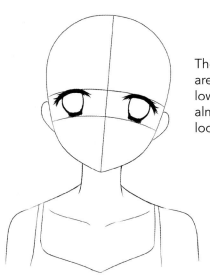

The eyelids are slightly lowered. It's almost a sad look.

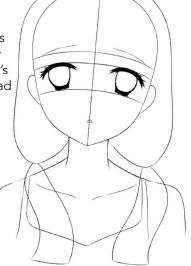

The pigtails wind around and flop over her shoulders.

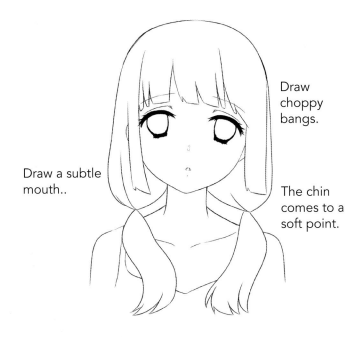

Draw choppy bangs.

Draw a subtle mouth..

The chin comes to a soft point.

Color selection underscores the character type. Her outfit is muted, tamping down any emotional exuberance. However, she has brilliant blue eyes, which is a reminder that she's still got a spark of life deep within.

She acts guarded until she knows you.

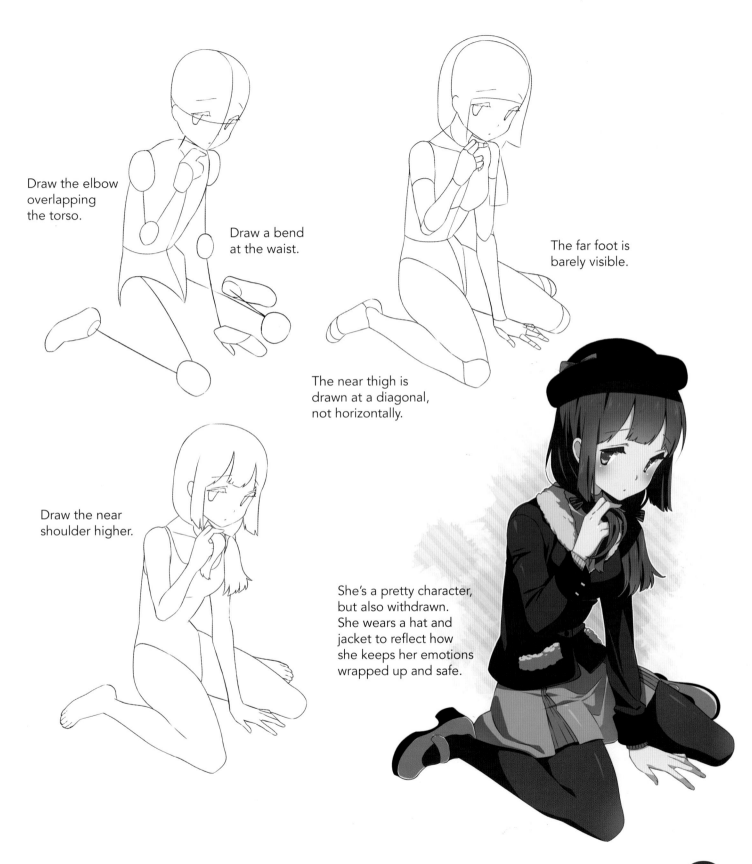

Draw the elbow overlapping the torso.

Draw a bend at the waist.

The far foot is barely visible.

The near thigh is drawn at a diagonal, not horizontally.

Draw the near shoulder higher.

She's a pretty character, but also withdrawn. She wears a hat and jacket to reflect how she keeps her emotions wrapped up and safe.

YANDERE

And now we turn to the notorious *Yandere*. This one does not know the meaning of the word *breakup*. If her boyfriend shows interest in another girl, this formerly well-behaved student becomes insanely vengeful. A typical comment to her boyfriend would be, "You can date other people. But you'll be responsible for what happens to them."

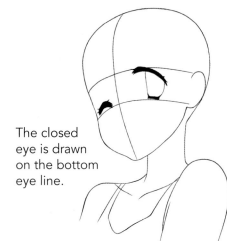

The closed eye is drawn on the bottom eye line.

Use the center guideline to help you draw the head tilting slightly to the left.

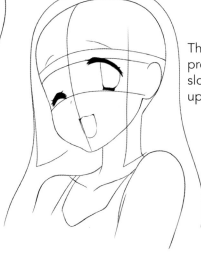

There's a pronounced slope to the upper eyelid.

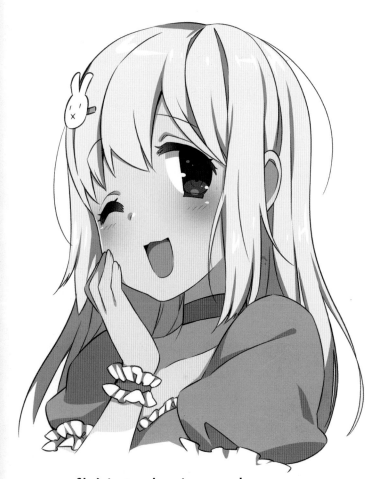

She's just as charming as can be. (Until she isn't!)

Flop the hair in front and in back of the head, to soften her look.

Draw a vertical-type smile (more up-and-down than side-to-side).

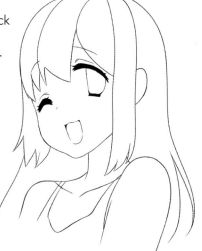

Straighten this leg.

The locked leg pushes the hip outward for a fun posture.

Draw this elbow lower.

Bend knee inward.

Point the top elbow at the viewer.

Draw hands first, then the handle.

Foot is balanced on toes

1OOKG

57

KAMIDERE

You may know someone like this. Or, god forbid, be related to someone like this. Or worse yet, be this type! The *Kamidere* is a narcissist. It's all about her. She demands admiration from everyone. Although she has few real friends, she doesn't want them anyway. She only wants followers.

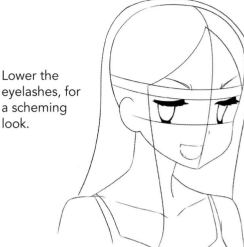

Lower the eyelashes, for a scheming look.

Draw downward angled eyebrows.

Draw the mouth to one side. (Things that are crooked or uneven create a dishonest impression.)

Pull back the hair on both sides of the part.

Mean little eyebrows, a sneaky smile, and a finger on her chin. Whatever she's thinking, you'd better hope it's not about you.

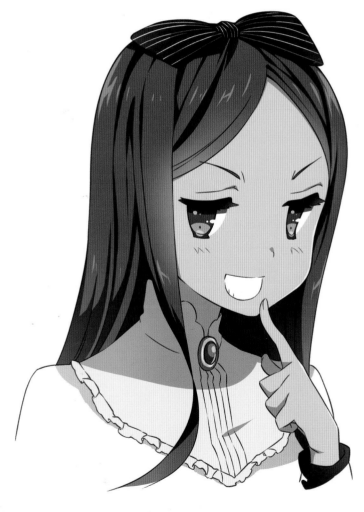

It's all about her!

58

It's important to bring one shoulder up to the chin. It sets the tone for her royal highness' seated pose.

Add a small bend at the waist, so she won't look stiff.

Point the toe.

Her elbow is overlapped by her hips.

Draw the top knee almost as high as the waist.

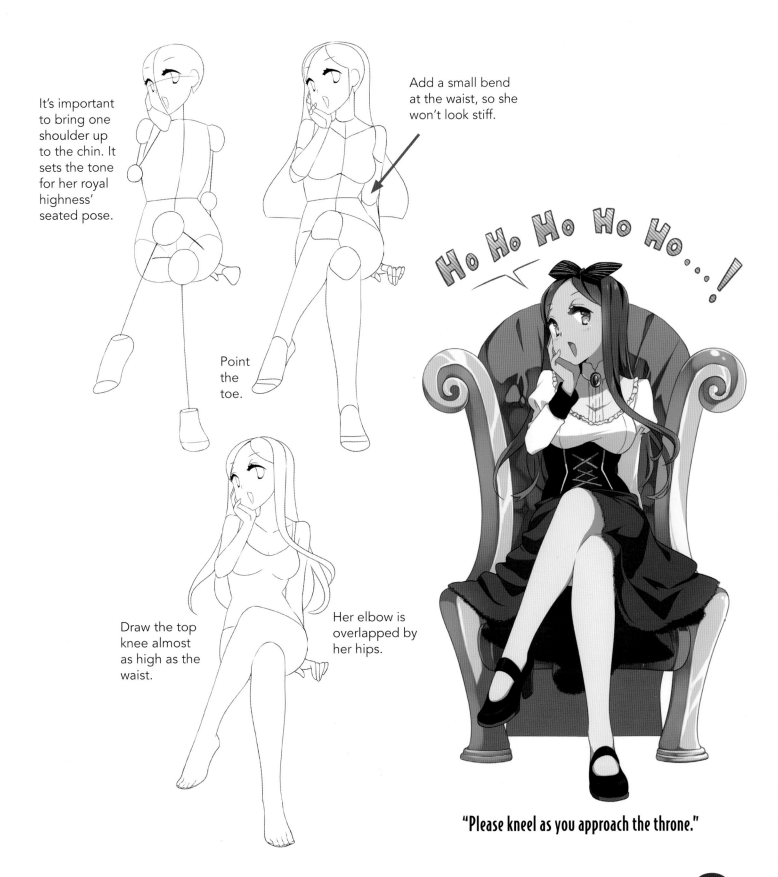

Ho Ho Ho Ho Ho...!

"Please kneel as you approach the throne."

HIMEDERE

The *Himedere* is the most amazing person on earth, at least according to her. And because of this amazing wonderfulness, she feels entitled to boss everyone around mercilessly.

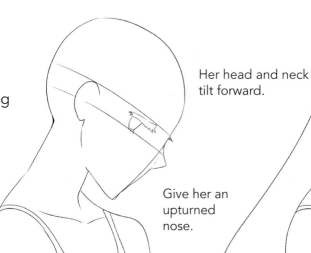

Her head and neck tilt forward.

Give her an upturned nose.

Draw a small grin inside the outline of the face.

The hair hangs down in front of the face.

Her black hair has some gray tones in it, which are used to indicate the strands. Without the lighter tones, it would appear to be a big mass of blackness. Sort of like a neutron star that has been blown-dry.

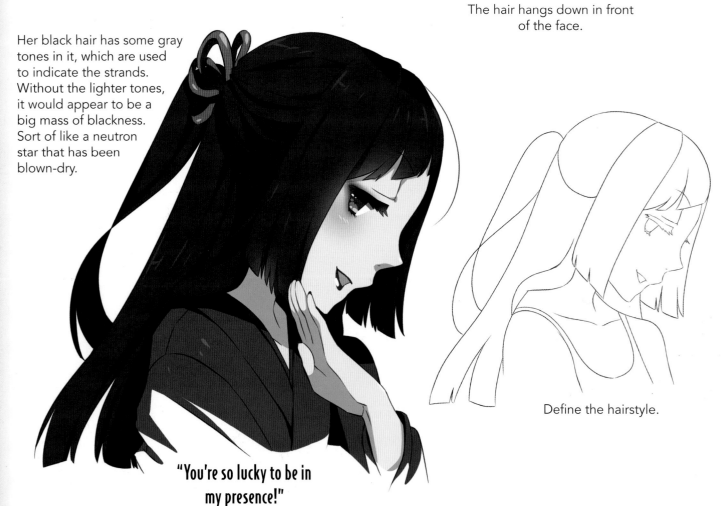

"You're so lucky to be in my presence!"

Define the hairstyle.

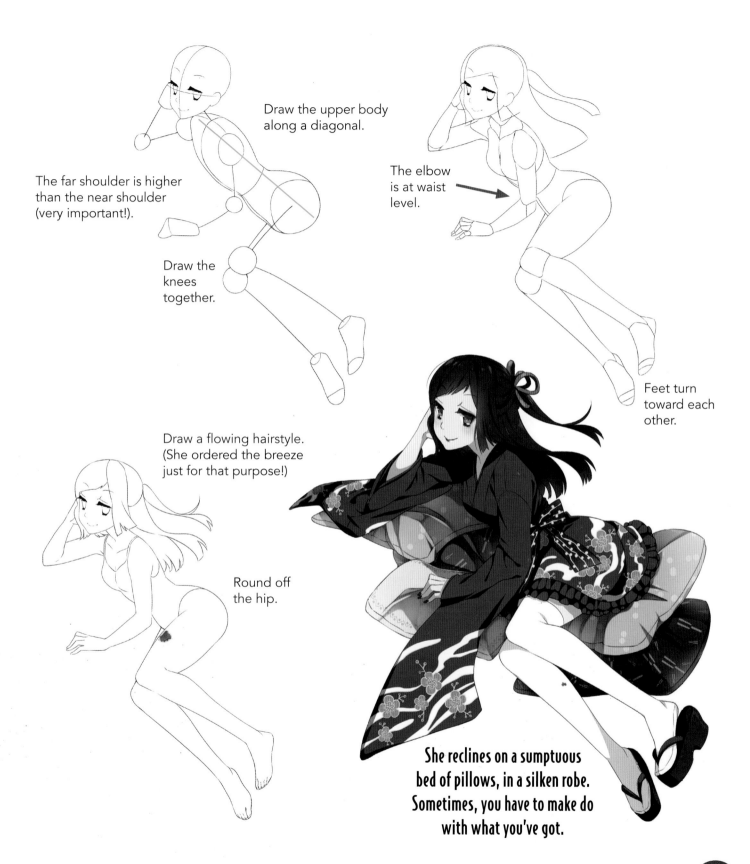

Draw the upper body along a diagonal.

The far shoulder is higher than the near shoulder (very important!).

Draw the knees together.

The elbow is at waist level.

Feet turn toward each other.

Draw a flowing hairstyle. (She ordered the breeze just for that purpose!)

Round off the hip.

She reclines on a sumptuous bed of pillows, in a silken robe. Sometimes, you have to make do with what you've got.

UNDERE

She's a bit of a stereotype, but that's part of the comedy. Unlike other characters, the *Undere* doesn't hide her infatuation. In fact, she'll say almost anything to stay on her boyfriend's good side. If he plays baseball, she'll take up woodworking and carve him a bat with little hearts on it. When he finally demands time alone, she'll find a secluded spot where they can do that together.

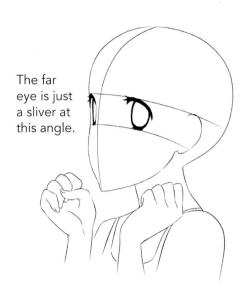

The far eye is just a sliver at this angle.

Draw the face at a 7/8 angle—that's almost a side view, but turned slightly toward the viewer. The centerline demonstrates this.

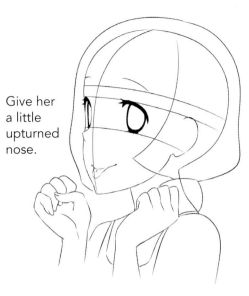

Give her a little upturned nose.

By drawing the mouth low on the face, you give her a funny look.

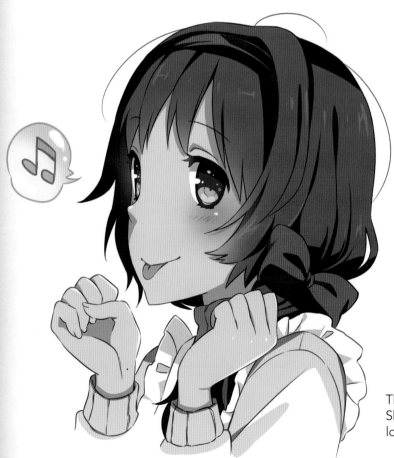

To convey excitement, draw the wrists facing each other, and bend both fists back.

The Undere is meek, but only on the surface. She actually has the drive of a locomotive—a locomotive made up of hearts and hugs.

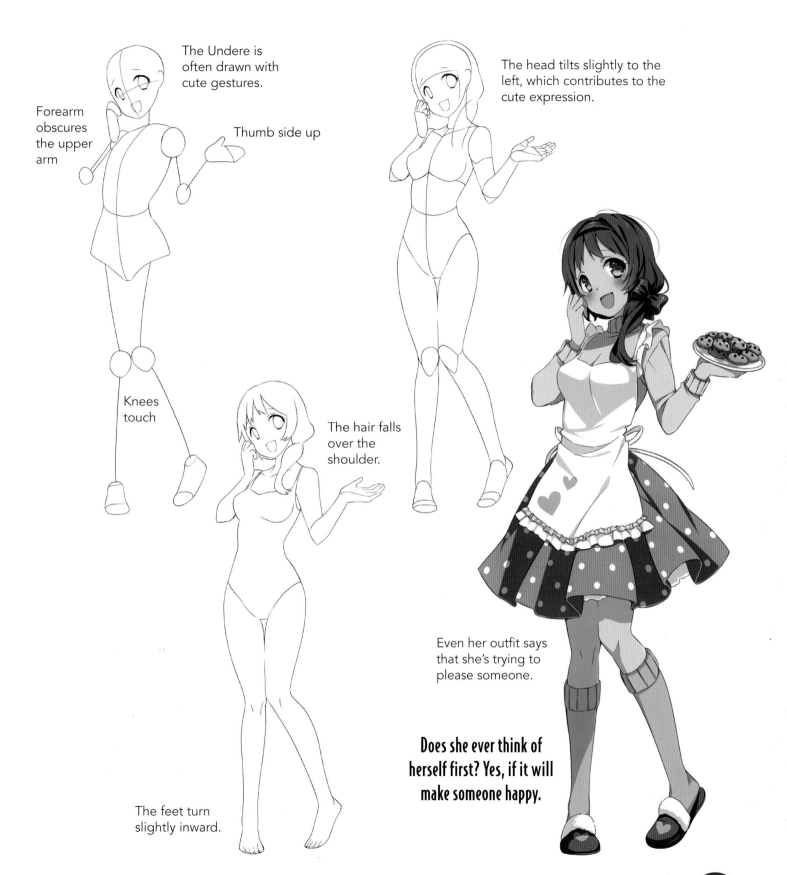

The Undere is often drawn with cute gestures.

Forearm obscures the upper arm

Thumb side up

Knees touch

The head tilts slightly to the left, which contributes to the cute expression.

The hair falls over the shoulder.

The feet turn slightly inward.

Even her outfit says that she's trying to please someone.

Does she ever think of herself first? Yes, if it will make someone happy.

More Essential Types

Although Dere characters are among the most popular anime girls, there are other fan favorites. These are based on personality types as well as their role in a story. Here's how to draw these eye-catching characters.

GENKI GIRL

The *Genki* girl is a popular type with an emotional range from excited to very excited. She has enough energy to power a small Hungarian village for a month. For New York City? Maybe ten minutes. Don't draw this character and drink coffee at the same time, or your head may explode.

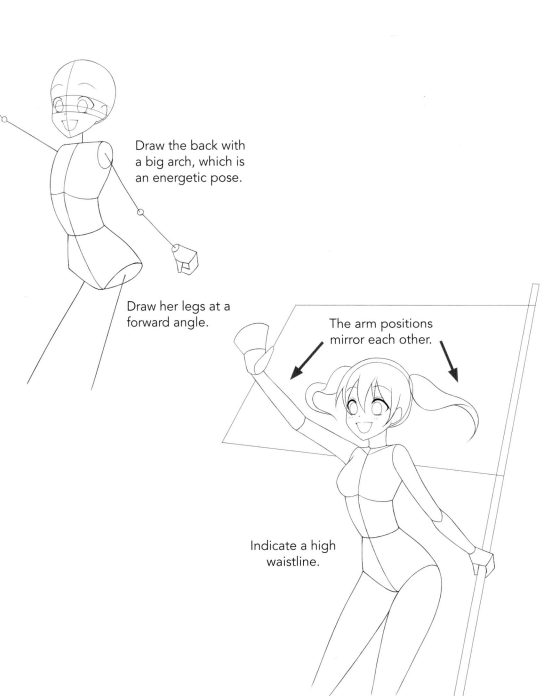

Draw the back with a big arch, which is an energetic pose.

Draw her legs at a forward angle.

The arm positions mirror each other.

Indicate a high waistline.

Spread fingers apart.

Draw the hair with pigtails that are going slightly bonkers.

Finish up the drawing with a colorful commotion, such as sound effects (the gold rectangular shapes), a floating heart, and small speckles of color.

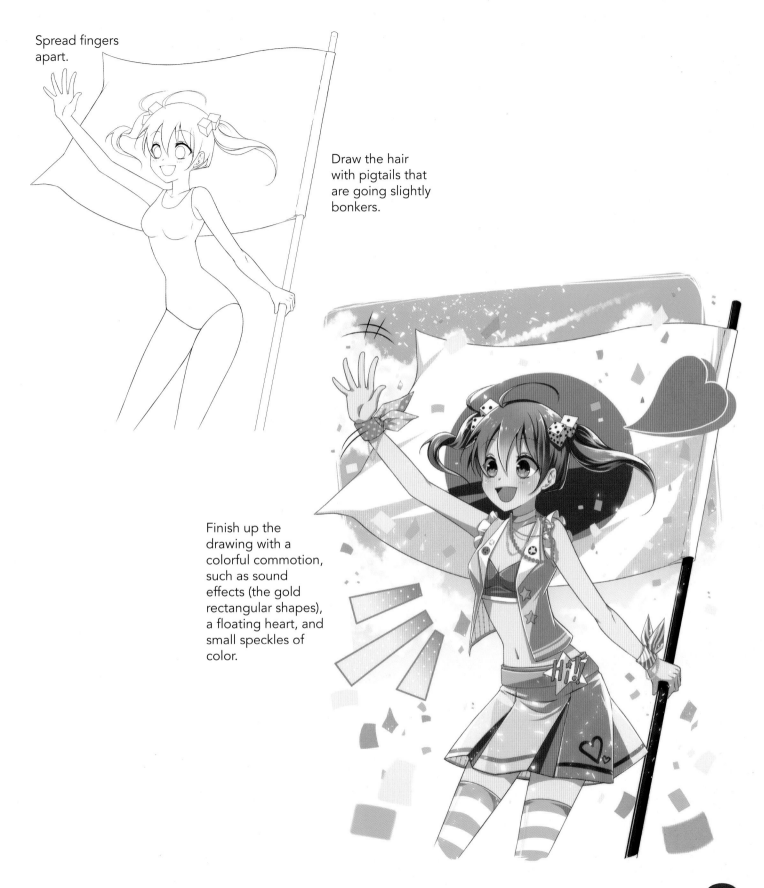

THE MUSIC FAN

Sometimes you need to escape your circumstances. Work is boring. You're learning all about *The Odyssey* in school. And your younger brother has just bought a drum set.

 The music loving character tunes it all out with a set of headphones. They're cheaper than therapy and work twice as well. She listens to golden oldies, which, for a high school student, means songs that are six weeks old.

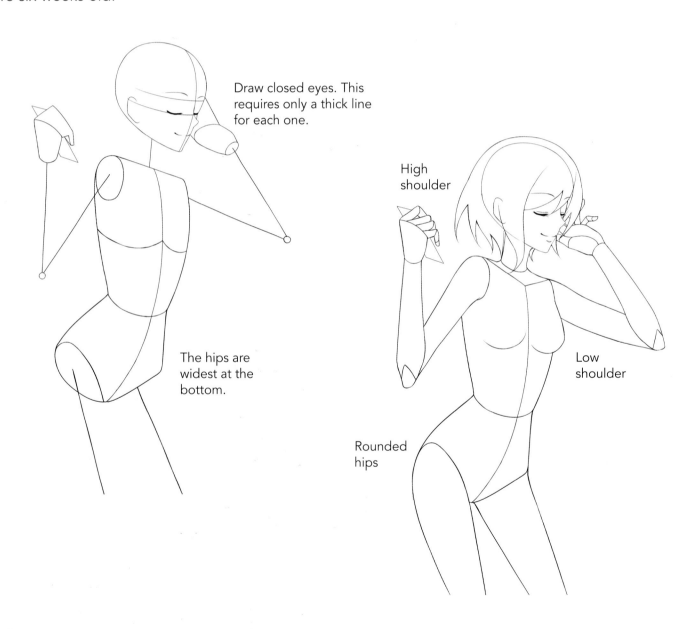

Draw closed eyes. This requires only a thick line for each one.

The hips are widest at the bottom.

High shoulder

Low shoulder

Rounded hips

The hair gets shaggy along the bottom.

Draw the hand palm-side up.

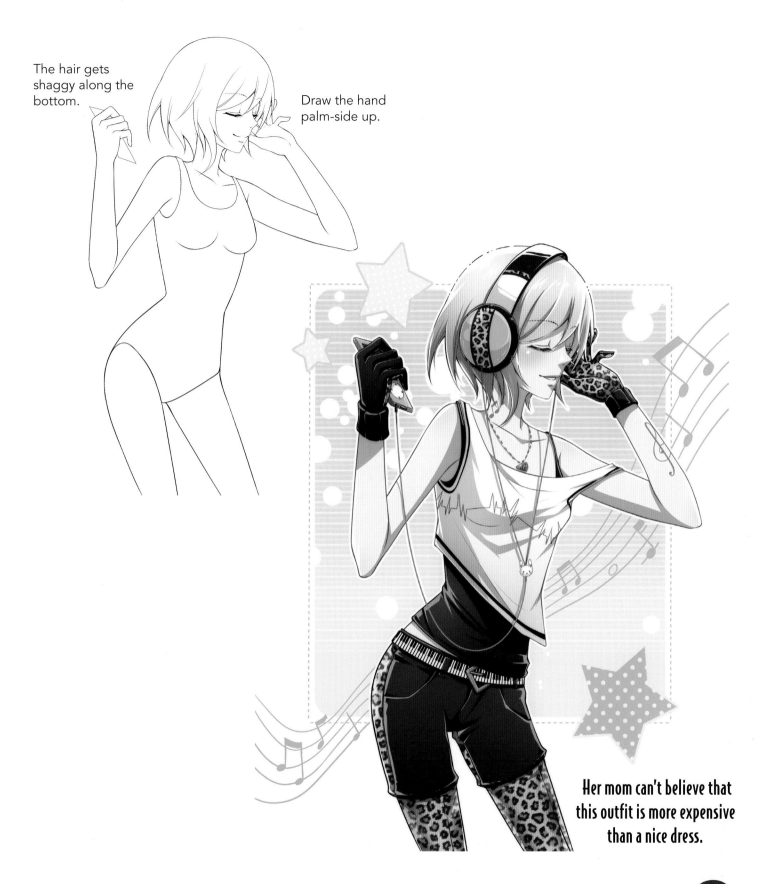

Her mom can't believe that this outfit is more expensive than a nice dress.

AMAZING POWERS

Behold the power of mind control. This talented girl knows how to manipulate energy into a disk, which she uses to zap people into becoming mindless entities. You may already know a few people who have been hit with it.

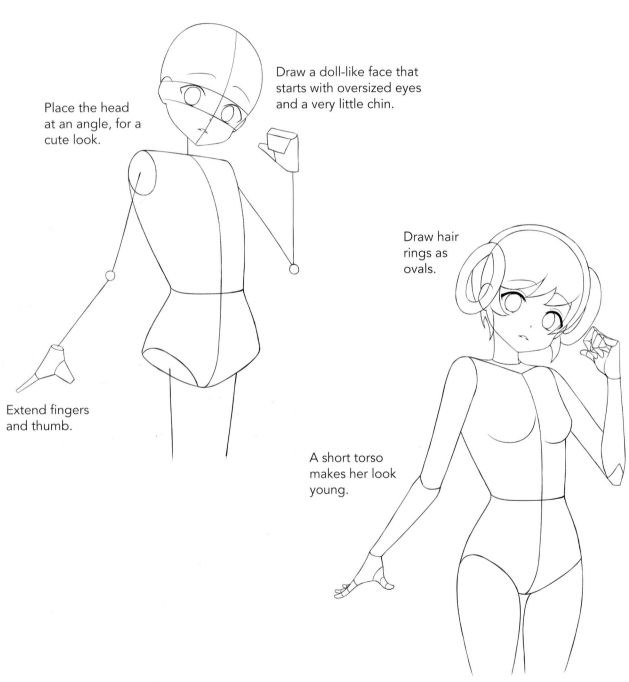

Place the head at an angle, for a cute look.

Draw a doll-like face that starts with oversized eyes and a very little chin.

Extend fingers and thumb.

Draw hair rings as ovals.

A short torso makes her look young.

Draw the hand with the "pinky" side (palm heel) facing out.

Elbow bends in

If you could have any special power, what would it be?

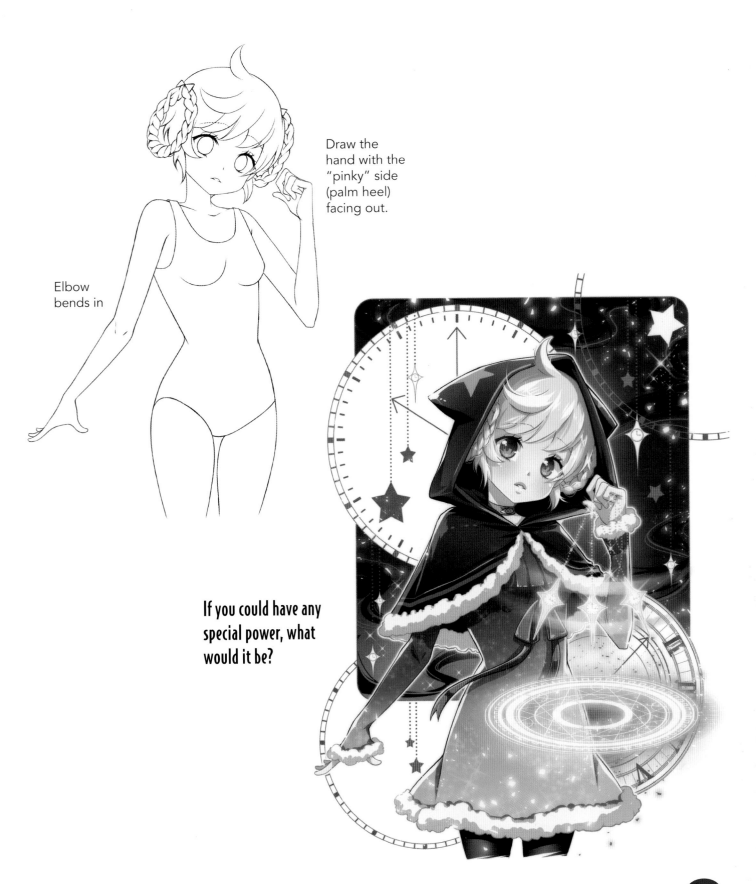

UNSCRUPLULOUS FRIEND

Why fight with a girl over a boy when you can ruin her life instead? This schemer is so obviously evil that it's amazing anyone would trust her. But no one realizes she's evil until it's too late.

Position the entire upper body within the circle.

Short post

Add a scoop to indicate the interior of the chair. Is it a chair? What the heck is that thing?

Knee emerges from underneath other leg.

At this angle, you should be able to see the underside of her legs.

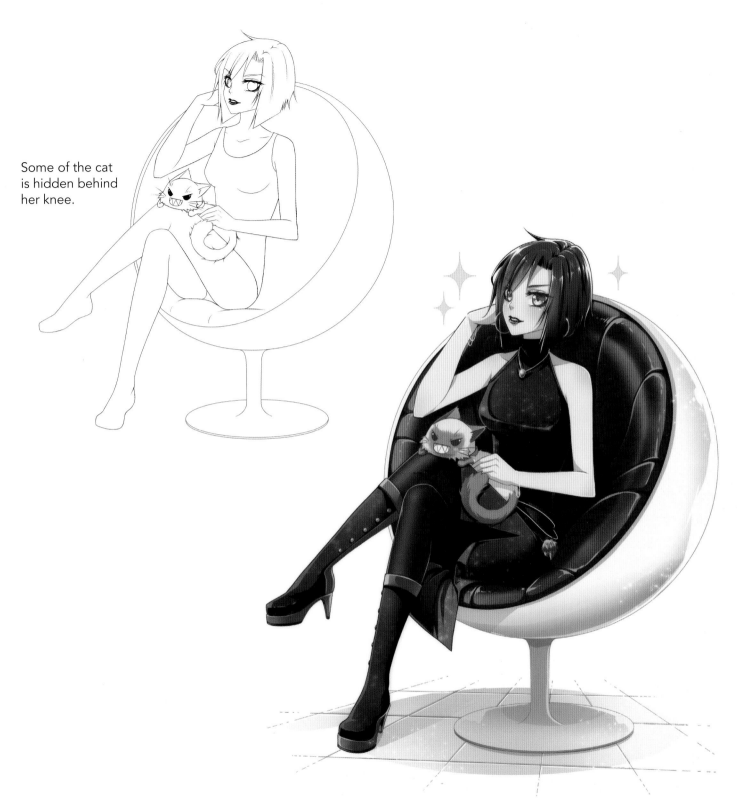

Some of the cat is hidden behind her knee.

Wicked characters only shop at high-end clothing stores.

COMPETITIVE GIRL

Hey guys, are you ready to go down in complete defeat? Then accept her challenge. This character type's goal in life is to beat the boys at their game. The most difficult part for boys is trying to convince your friends that you meant to lose.

Draw the head in a front angle.

Draw the body at a ¾ angle. (Note the center line running down the torso.)

Lift the near shoulder for a confident pose.

The chest area overlaps the upper arm.

She's showing the victory sign before they even play! Talk about intimidation.

PONK

Checkmate!

UNCERCOVER AGENT

Have you ever noticed that there are no poorly dressed spies? You can't find any spies with bad haircuts either. Maybe there's a finishing school for spies. This one looks like she graduated at the top of her class.

The agency has given her a jet-black outfit, so she can't be spotted at night. But they seemed to have overlooked the pink hair.

Draw the upper body and head on a diagonal to give her an aggressive pose.

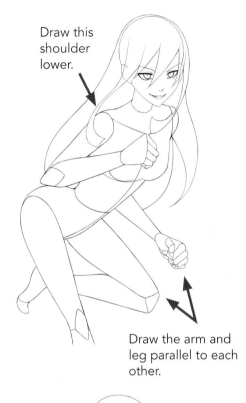

Draw this shoulder lower.

Draw the arm and leg parallel to each other.

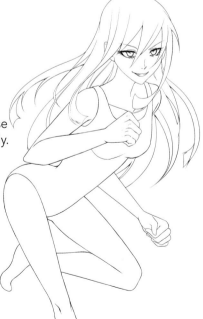

Keep the elbow close to the body.

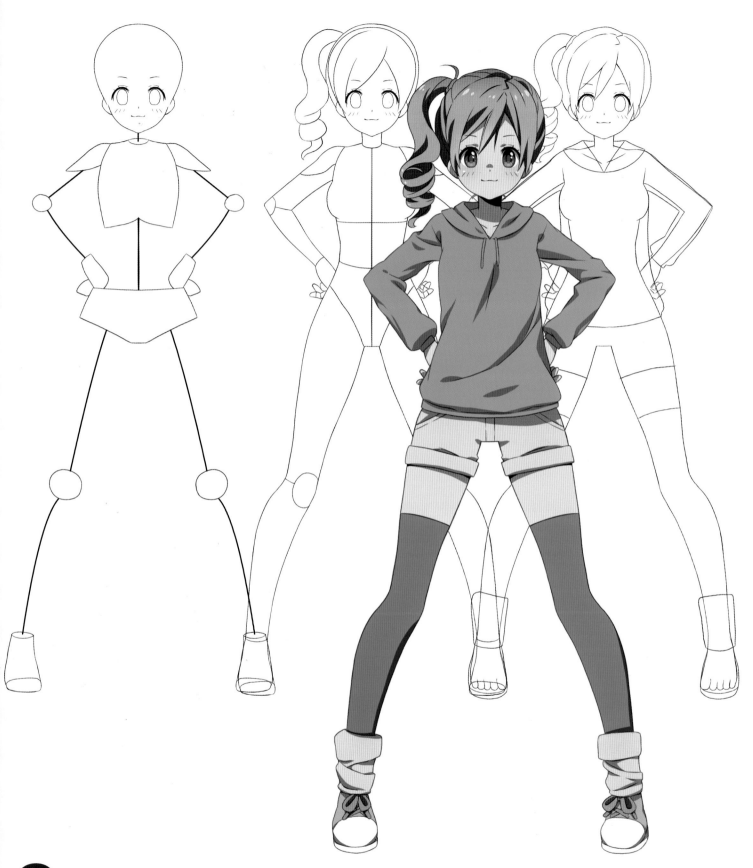

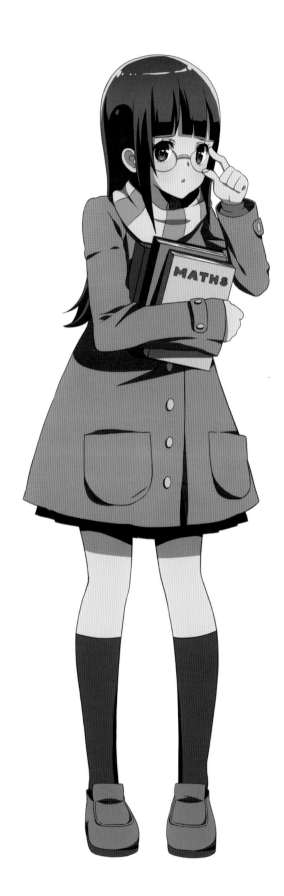

Dressing The Part

Have you ever heard the saying, "The outfit makes the character?" You have? No you haven't. I just made it up. Nevertheless, it's actually true. Most artists only draw clothes that look pretty. There's nothing wrong with that, but we're going to take it a step further. From bubbly personalities to introverts, we're going to draw outfits designed to create the most popular types of anime characters. ∎

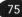

Clothing and Character Types

Let's look at how personalities can be expressed through various styles of outfits. When creating clothing for your characters, think about how color and details, such as patterns and layers, can be used to create the overall impression.

SUGARY

Her never-tiring optimism is very appealing to fans. If you're down in the dumps, she'll cheer you up. If you're angry, she'll cheer you up. If you've had enough of being cheered up, she'll cheer you up.

Draw the head tilted slightly to the left.

Start by drawing the major sections of the body: rib cage and hips.

The hair fans out at the lower back.

The back of the hand faces the viewer.

Slight bend

Straight

76

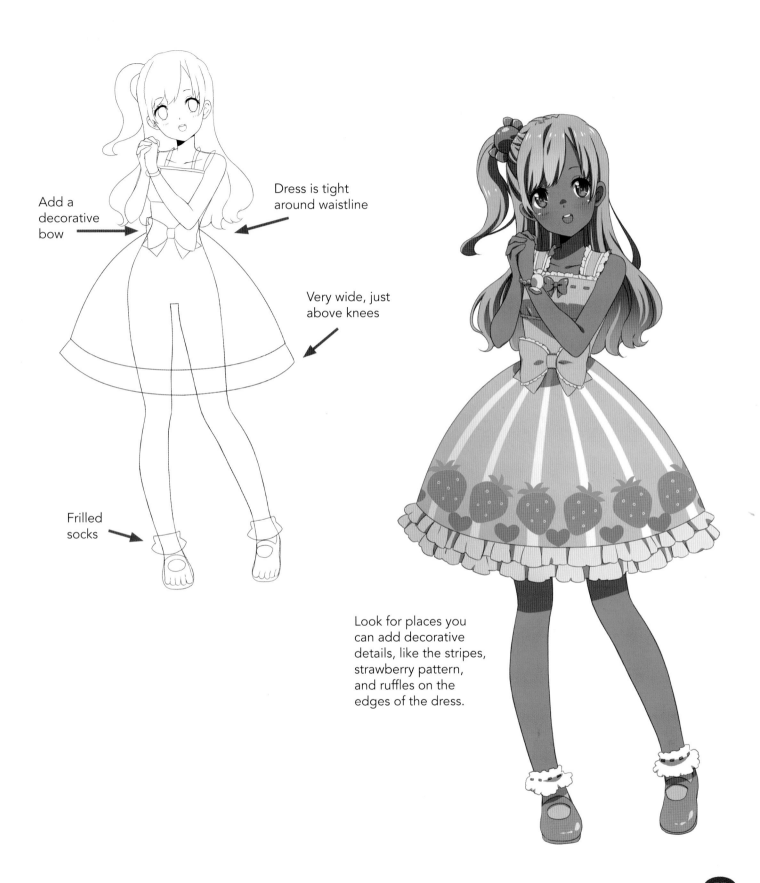

Add a decorative bow

Dress is tight around waistline

Very wide, just above knees

Frilled socks

Look for places you can add decorative details, like the stripes, strawberry pattern, and ruffles on the edges of the dress.

INTROVERT

Everyone feels down in the dumps sometimes. I get that way when I try on the pants I wore in college. Her buttoned up jacket is synonymous with a character that is wrapped up tightly. But a close friend can get her to laugh.

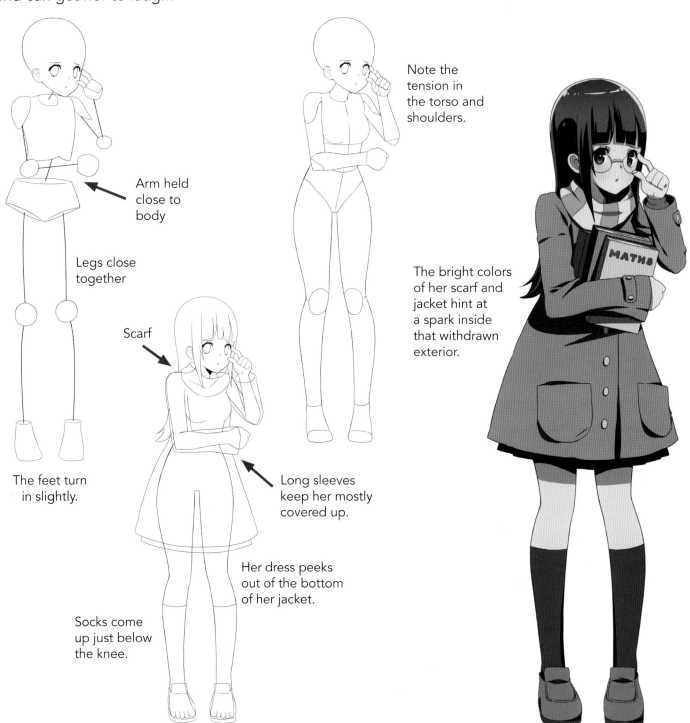

Arm held close to body

Legs close together

The feet turn in slightly.

Note the tension in the torso and shoulders.

Scarf

Long sleeves keep her mostly covered up.

Her dress peeks out of the bottom of her jacket.

Socks come up just below the knee.

The bright colors of her scarf and jacket hint at a spark inside that withdrawn exterior.

ADVENTUROUS

Bold, fun, and adventurous, this type has an outfit as lively as her personality. Her adventures are often suspenseful, like being the only witness to a crime and following the bad guys to their hideout. Or, she can be even more daring, like trying the Salisbury steak at the school cafeteria. I'd rather take my chances with the bad guys.

A breezy, unstructured outfit allows her to be spontaneous.

Big outward curve to torso

Arms thrust behind head

Knees together

Thumb side of hand is up

Toes point down

Loose top

Jumble the vest to indicate motion.

Short, pleated skirt with flouncy trim

Wide opening at the top

INDEPENDENT

Her outfit tells the audience that she's an independent thinker. She has creative ideas and follows her own muse. She can wear a polished outfit or put something simple together for herself. She's a fun character type who has self-esteem and doesn't follow the group.

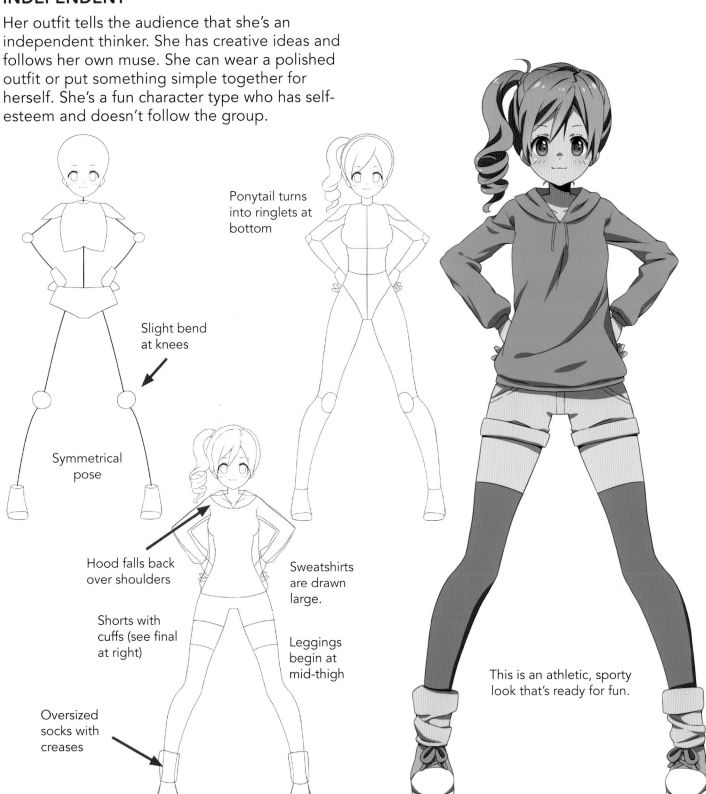

Ponytail turns into ringlets at bottom

Slight bend at knees

Symmetrical pose

Hood falls back over shoulders

Shorts with cuffs (see final at right)

Sweatshirts are drawn large.

Leggings begin at mid-thigh

Oversized socks with creases

This is an athletic, sporty look that's ready for fun.

MODEST STUDENT

This charming character type suffers from low self-esteem. She doesn't realize that she's a talented artist, so she doesn't show her drawings to anyone. Do you know someone like that?

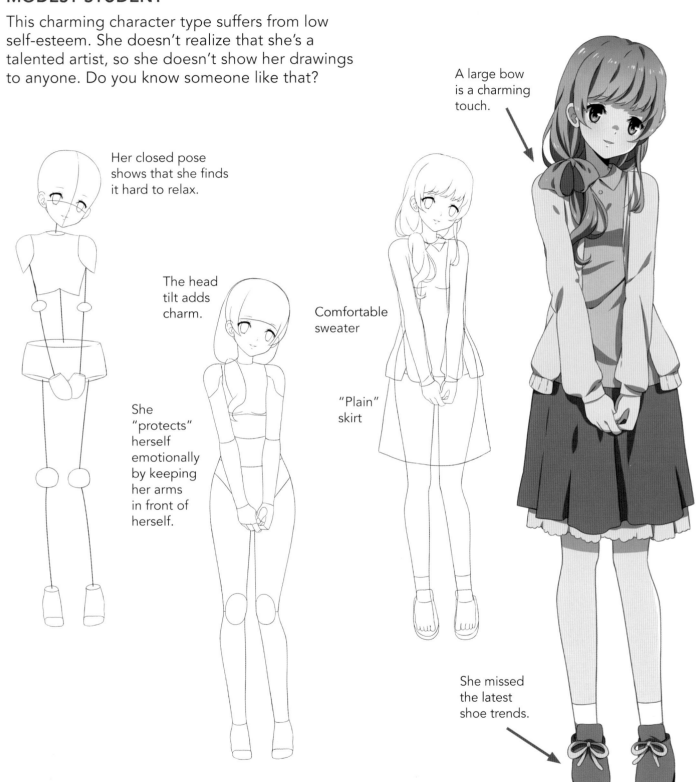

Her closed pose shows that she finds it hard to relax.

The head tilt adds charm.

She "protects" herself emotionally by keeping her arms in front of herself.

Comfortable sweater

"Plain" skirt

A large bow is a charming touch.

She missed the latest shoe trends.

FROM A DARK KINGDOM

You might see this pretty character in a land far away. The main elements to this outfit are: frills, darkness, some more darkness, a lot of material, and darkness.

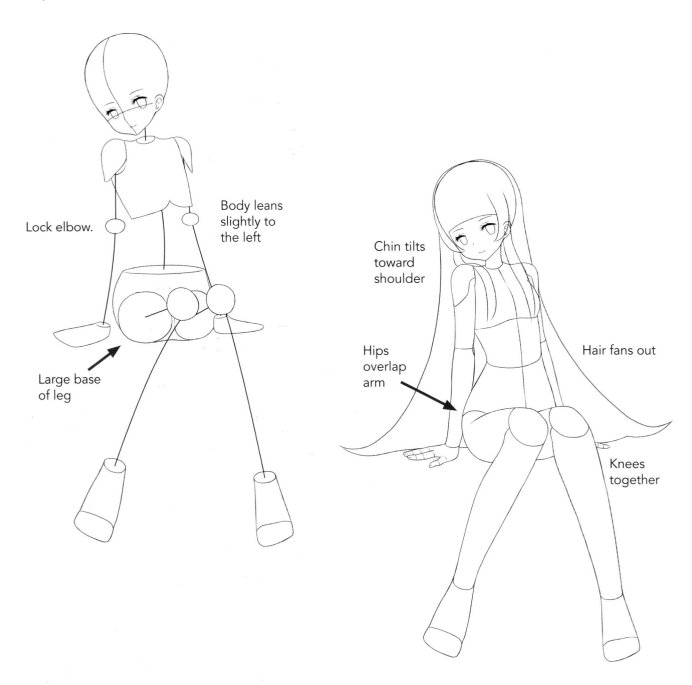

Lock elbow.

Body leans slightly to the left

Large base of leg

Chin tilts toward shoulder

Hips overlap arm

Hair fans out

Knees together

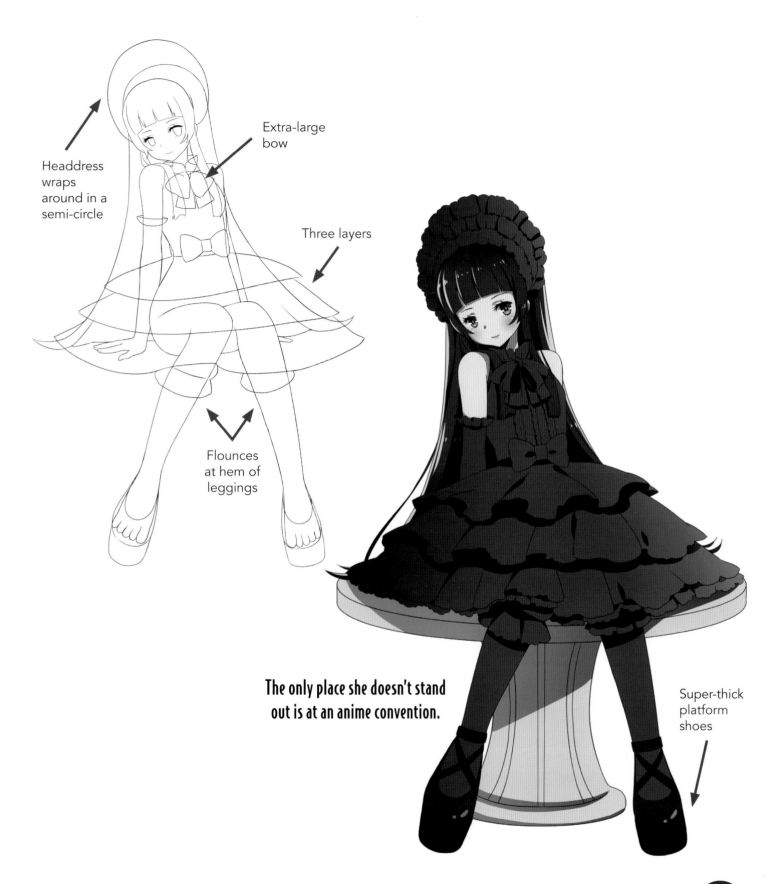

Headdress wraps around in a semi-circle

Extra-large bow

Three layers

Flounces at hem of leggings

The only place she doesn't stand out is at an anime convention.

Super-thick platform shoes

Schoolgirl Styles

School uniforms are the default outfit for most of your anime girl characters. There are a great many variations you can create. Here are some popular outfits.

JACKET AND SKIRT

The jacket and skirt is the most popular school uniform in anime.

Center line shows the torso leaning to the left.

Shorten calf, due to perspective.

Jacket falls to the hips.

Pleated skirts move; they're never stiff.

This knee overlaps the other knee.

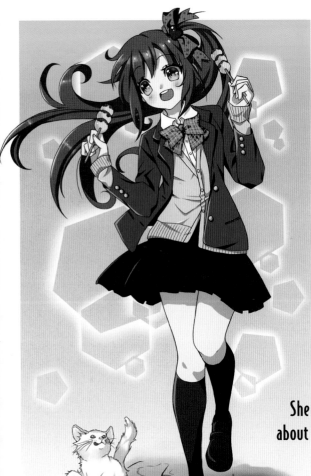

She looks pretty excited about that snack. I wonder if she'll share it?

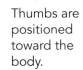

Thumbs are positioned toward the body.

Draw an uneven hem.

BEGUILING

This curiously intriguing character gets her look from a long, flowing skirt that catches the breeze.

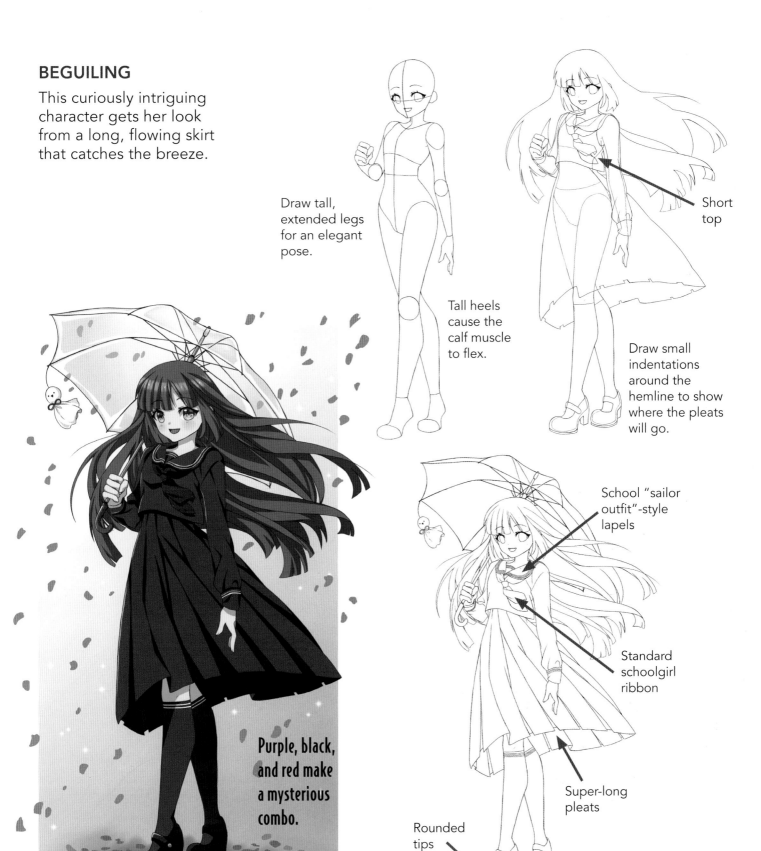

Draw tall, extended legs for an elegant pose.

Tall heels cause the calf muscle to flex.

Short top

Draw small indentations around the hemline to show where the pleats will go.

Purple, black, and red make a mysterious combo.

School "sailor outfit"-style lapels

Standard schoolgirl ribbon

Super-long pleats

Rounded tips

HARAJUKU STYLE

This fun school outfit is based on the *Harajuku* pop style. Harajuku is an area surrounding the Harajuku Station in Tokyo. It's filled with pop culture fans, some who wear full-blown anime-style outfits. It's like a mini-anime convention outdoors.

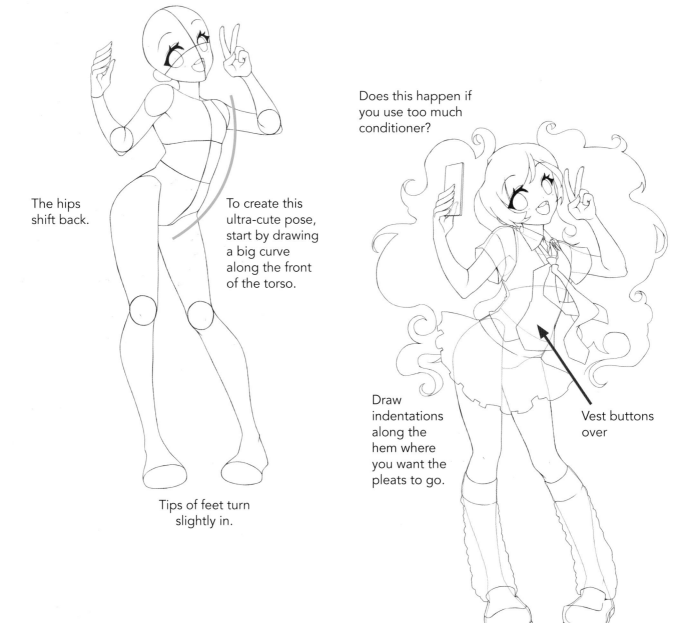

The hips shift back.

To create this ultra-cute pose, start by drawing a big curve along the front of the torso.

Tips of feet turn slightly in.

Does this happen if you use too much conditioner?

Draw indentations along the hem where you want the pleats to go.

Vest buttons over

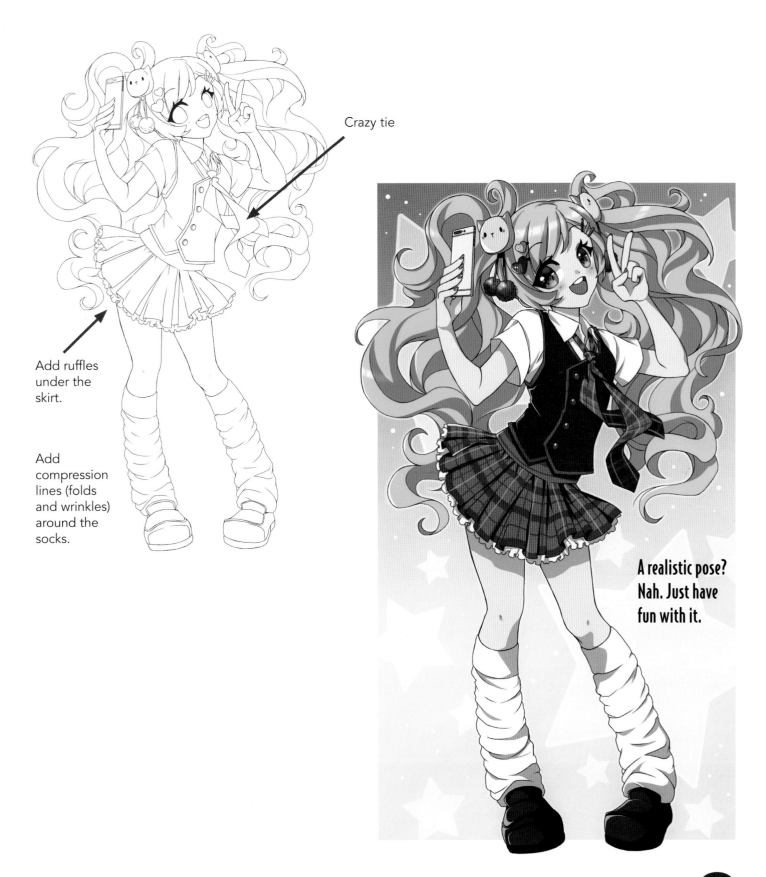

Crazy tie

Add ruffles under the skirt.

Add compression lines (folds and wrinkles) around the socks.

A realistic pose? Nah. Just have fun with it.

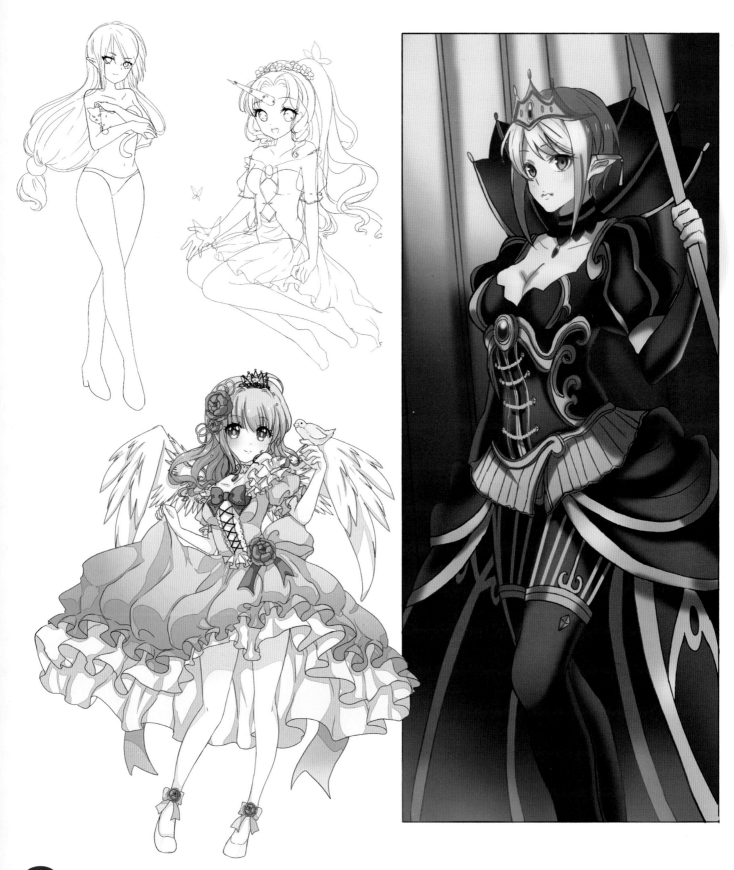

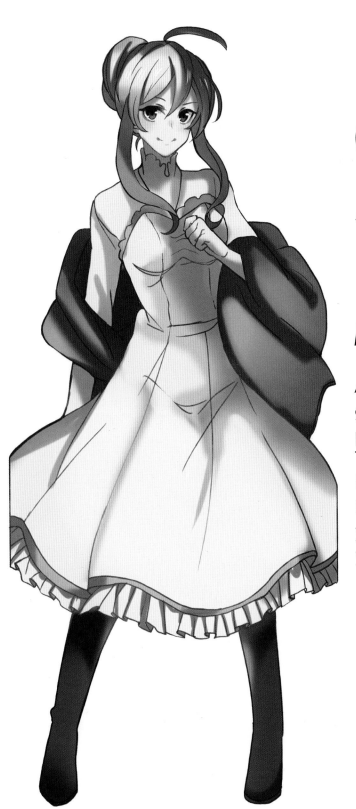

Beautiful Stars of Anime

Anime characters belong to various genres. Some character types are so popular that they dominate their category. These category winners attract a big fan base with devoted watchers of the series in which they appear. Maybe you'll find your own favorites in this chapter. I know you'll love drawing them. ■

Fan Favorites

In manga, the characters are drawn within comic panels. In anime, camera shots are used. In this chapter, we'll frame the characters within borders to mimic the camera lens.

HERO—LEGEND GENRE

The legend genre has three elements: an appealing hero, a historical setting, and an adventure. Let's focus on creating a beautiful hero whose costume suggests a place out of time.

The flowing scarf is more of a device than a real part of the outfit. It's used to add a touch of elegance.

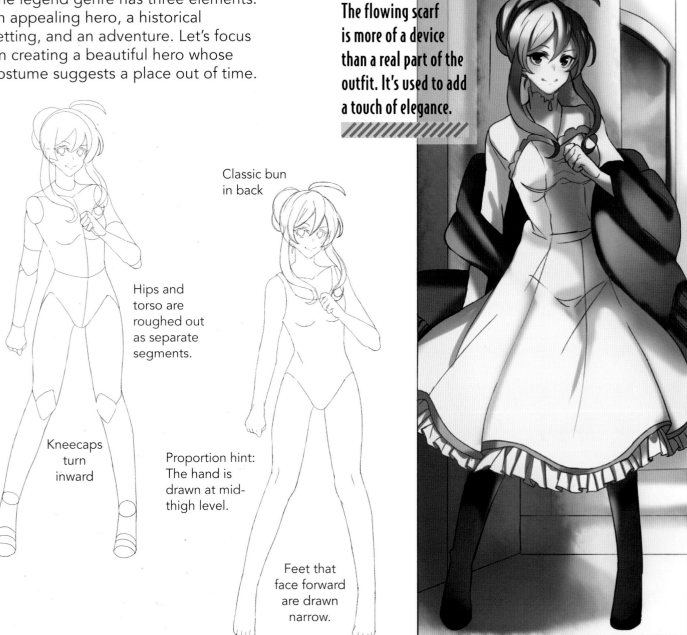

Hips and torso are roughed out as separate segments.

Classic bun in back

Kneecaps turn inward

Proportion hint: The hand is drawn at mid-thigh level.

Feet that face forward are drawn narrow.

DARK EMPRESS—KINGDOM GENRE

You might be wondering why this powerful character looks so gentle. Her beautiful look offsets her war-like costume. She is neither solely powerful nor solely beautiful, but a combination of both. Contradictions make for interesting characters.

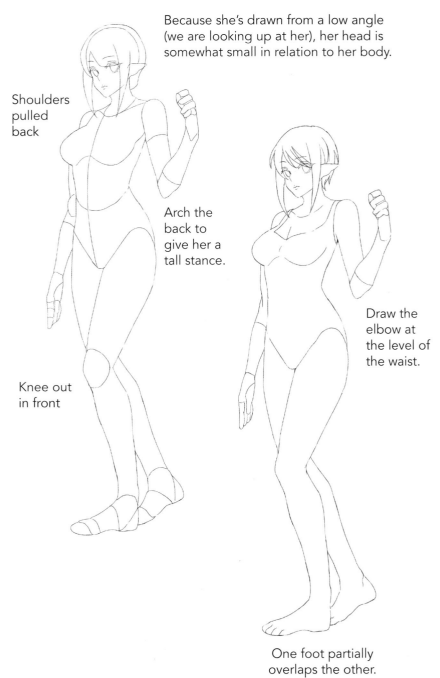

Shoulders pulled back

Because she's drawn from a low angle (we are looking up at her), her head is somewhat small in relation to her body.

Arch the back to give her a tall stance.

Knee out in front

Draw the elbow at the level of the waist.

One foot partially overlaps the other.

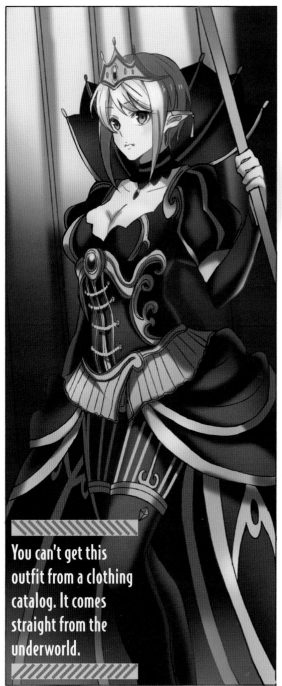

You can't get this outfit from a clothing catalog. It comes straight from the underworld.

GHOSTLY PRESENCE—PARANORMAL GENRE

Some ghosts scare people with floating candelabras and other cheesy parlor tricks. Not so with anime ghosts. These lovely souls have been banished from the Land of the Living. She yearns to return. She misses her friends. But more than anything, she misses central heating, which beats the heck out of cold, haunted houses.

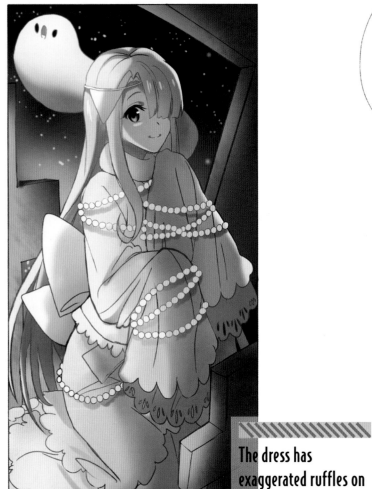

The dress has exaggerated ruffles on the sleeves and hem. She spent a lot of time sewing it. To bad that no one can see it.

Draw the hands close to the body to convey timidity.

The long hair widens out at the bottom.

The legs are drawn at an angle.

Flop some hair over the forehead to create loose bangs.

Even though she's kneeling, the torso is upright as if she were standing.

GUARDIAN—ACTION-ADVENTURE GENRE

Kick, punch, repeat. As children, we're told to talk things out calmly rather than fight about it. As a mature adult, I agree with that. However, no anime fan ever said, "That scene was awesome because of the way the characters resolved their differences intelligently!" Therefore, my friends, let's aspire to the ideal of level-headedness while drawing characters that still kick butt.

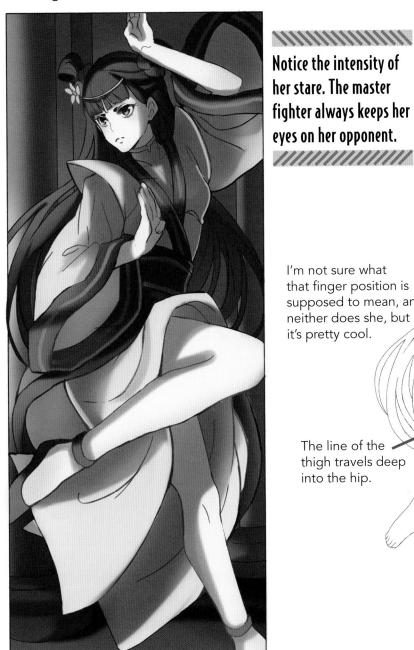

Notice the intensity of her stare. The master fighter always keeps her eyes on her opponent.

Draw long, dynamic hair that sweeps around the figure.

The torso makes a big curve toward the left.

Foot placed out ahead of the body

I'm not sure what that finger position is supposed to mean, and neither does she, but it's pretty cool.

The line of the thigh travels deep into the hip.

FUN SCHOOLGIRL—SLICE OF LIFE GENRE

When anime artists draw schoolgirl characters, they often strike a balance between pretty and clownish. This appealing combination makes anime characters like her very popular.

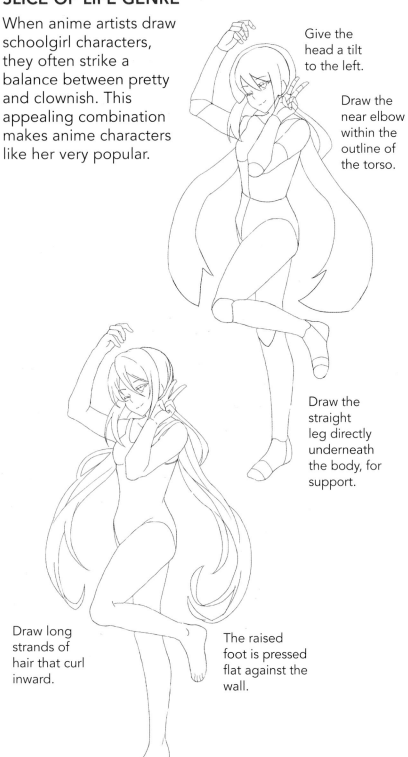

Give the head a tilt to the left.

Draw the near elbow within the outline of the torso.

Draw the straight leg directly underneath the body, for support.

Draw long strands of hair that curl inward.

The raised foot is pressed flat against the wall.

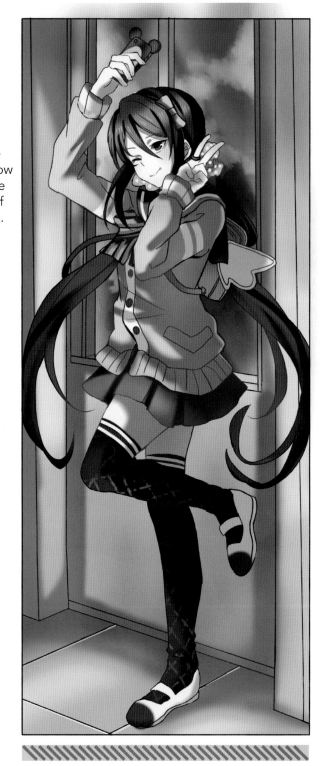

The random placement of her arms reflects excess energy looking for an outlet.

COUNTRY GIRLS—HISTORICAL GENRE

Characters that live in rural areas wear simpler clothes. There are no high-end outlet stores in the woods. Therefore, her clothes must look sturdy. This country girl dreams about one day moving to the big city, where she can get her own apartment with a big screen TV, a walk-in closet, and a parking spot for her horse. She's not entirely clear on the concept.

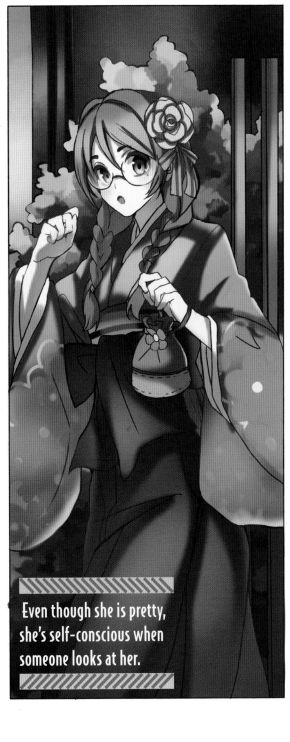

Even though she is pretty, she's self-conscious when someone looks at her.

Draw her hands up. so she looks busy.

Draw braided ponytails in front of the shoulders. This hairstyle creates a modest look, in keeping with the character.

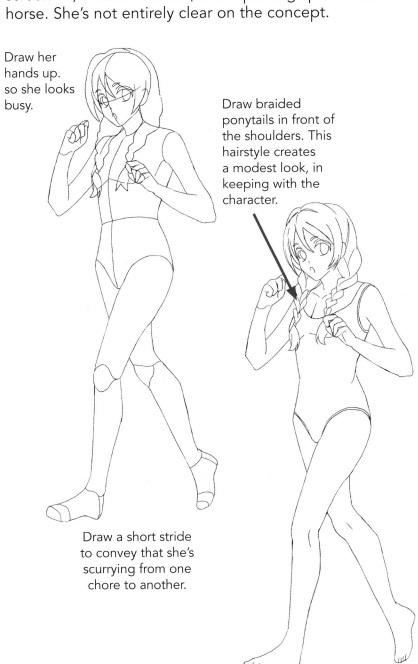

Draw a short stride to convey that she's scurrying from one chore to another.

Celestial Beings

These star characters are quite popular, but what exactly are celestial beings? They are dreamy, beautiful creatures often drawn with flowing hair and silky costumes that appear to float in slow motion. They're like a vision that's close enough to see, though it remains at a distance.

PRINCESS ANGEL

This princess is a heavenly being. She's a beautiful, benevolent spirit with hypnotic eyes. She has many fancy dresses like this one, but she doesn't own a wand. Why not? She already maxed out her celestial credit card.

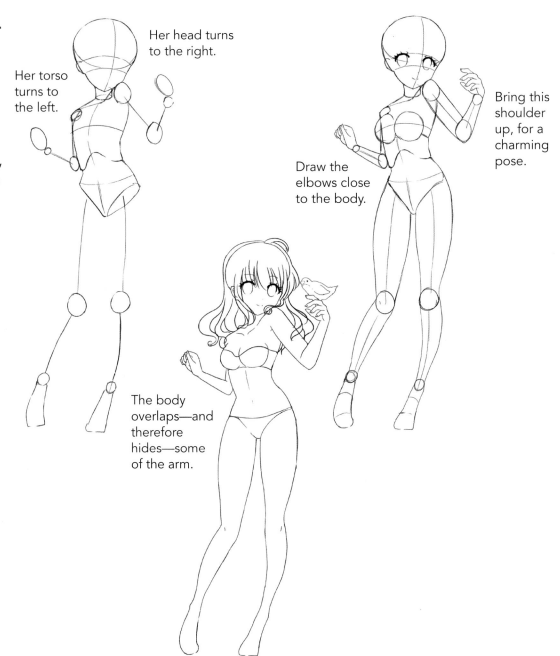

Her head turns to the right.

Her torso turns to the left.

Bring this shoulder up, for a charming pose.

Draw the elbows close to the body.

The body overlaps—and therefore hides—some of the arm.

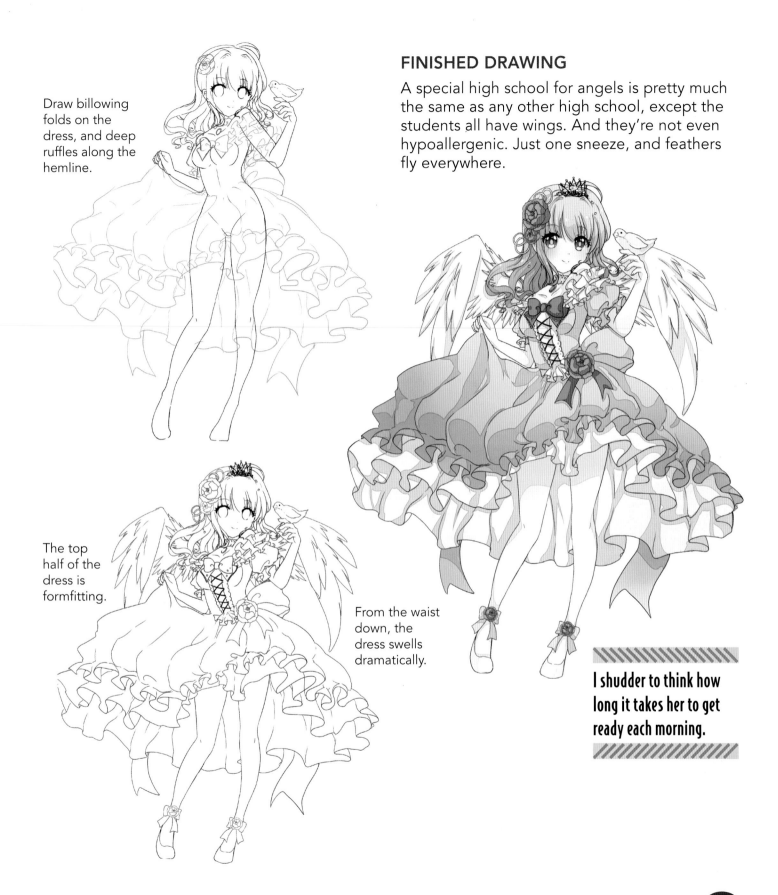

Draw billowing folds on the dress, and deep ruffles along the hemline.

FINISHED DRAWING

A special high school for angels is pretty much the same as any other high school, except the students all have wings. And they're not even hypoallergenic. Just one sneeze, and feathers fly everywhere.

The top half of the dress is formfitting.

From the waist down, the dress swells dramatically.

I shudder to think how long it takes her to get ready each morning.

97

RAINBOW GODDESS

The cool thing about goddess characters is that they can be drawn in amazing environments: rainbows, clouds, and streaks of starlight. Goddesses generally look happy, serene, and even joyous. And why not? They don't have to sit in traffic like the rest of us. Another perk.

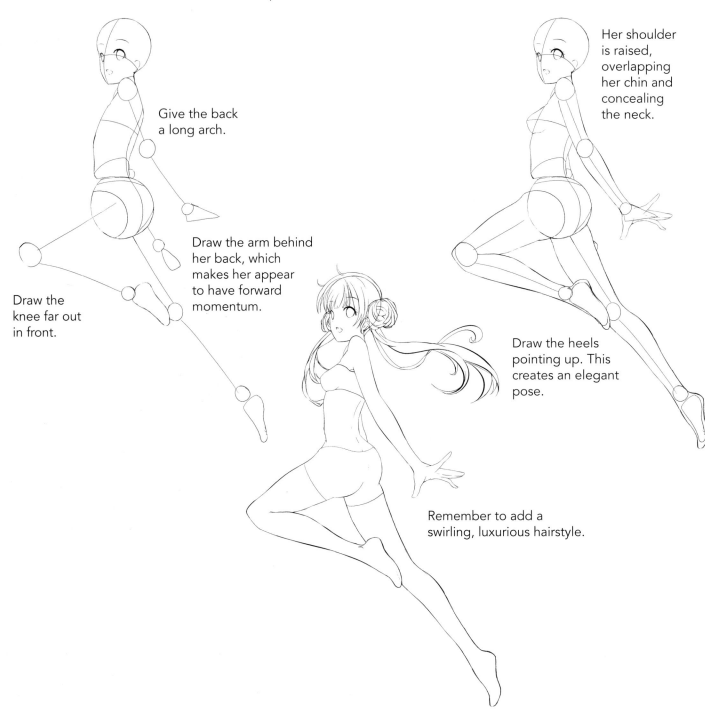

Give the back a long arch.

Draw the arm behind her back, which makes her appear to have forward momentum.

Draw the knee far out in front.

Her shoulder is raised, overlapping her chin and concealing the neck.

Draw the heels pointing up. This creates an elegant pose.

Remember to add a swirling, luxurious hairstyle.

Draw a hair bun and
finish it with a ribbon.

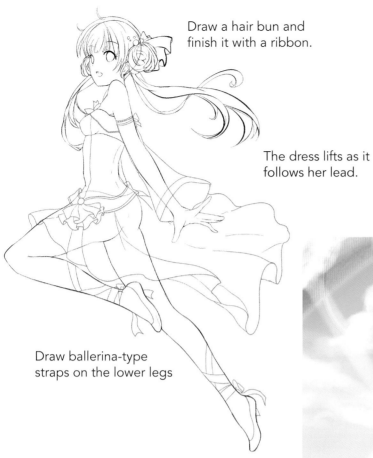

The dress lifts as it
follows her lead.

Draw ballerina-type
straps on the lower legs

FINISHED DRAWING

Draw everything so that it
flows gracefully, including
the hair, ribbons, sleeves,
and dress.

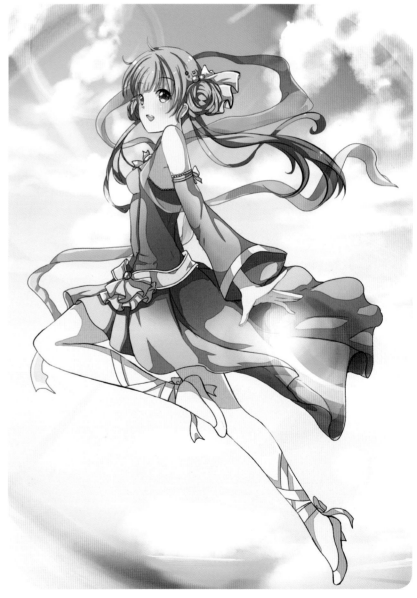

Man, does it look breezy
up there. I don't know why
they don't make sweaters
for these characters.

BEAUTIFUL SORCERESS

Let's do a thought experiment: Say you want to draw a sorceress, but you don't want to include any fire-and-brimstone stuff. How would you approach it? Would you draw a pretty face and flowing hair? Would you give her stylish boots and a cape? Would you surround her with mystical powers? If you answered "yes" to all three, you are in the zone.

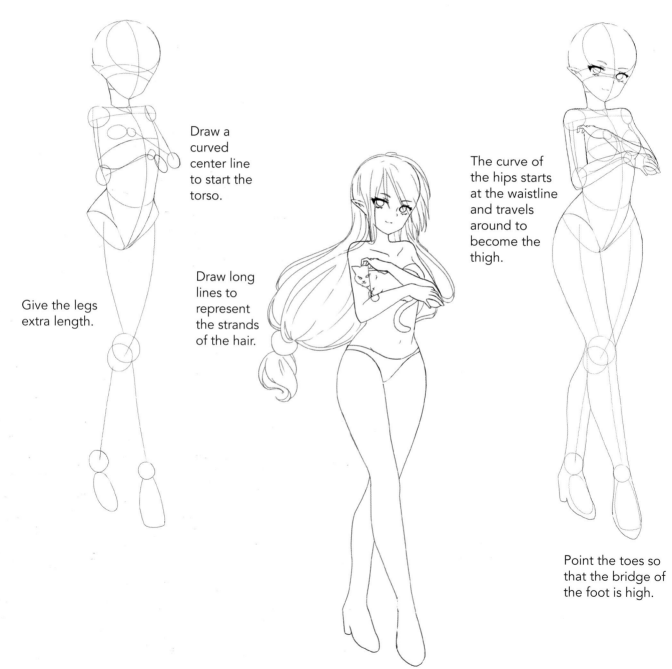

Draw a curved center line to start the torso.

Give the legs extra length.

Draw long lines to represent the strands of the hair.

The curve of the hips starts at the waistline and travels around to become the thigh.

Point the toes so that the bridge of the foot is high.

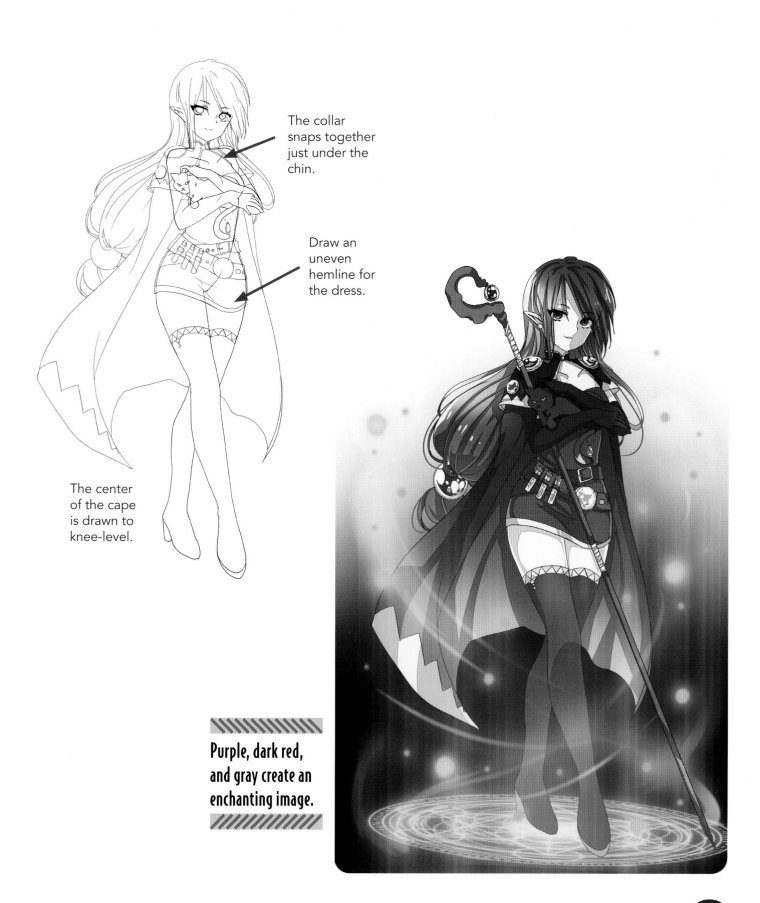

The collar snaps together just under the chin.

Draw an uneven hemline for the dress.

The center of the cape is drawn to knee-level.

Purple, dark red, and gray create an enchanting image.

UNICORN GIRL

Celestial characters often have a single, prominent feature, which says to the audience, "Hey, this is a special character!" What do you think the special feature is on this character? Is it the eyes? No. Is it the hair? No. Is it the horn sticking out of her forehead? No. I can't figure it out either. But let's draw her anyway!

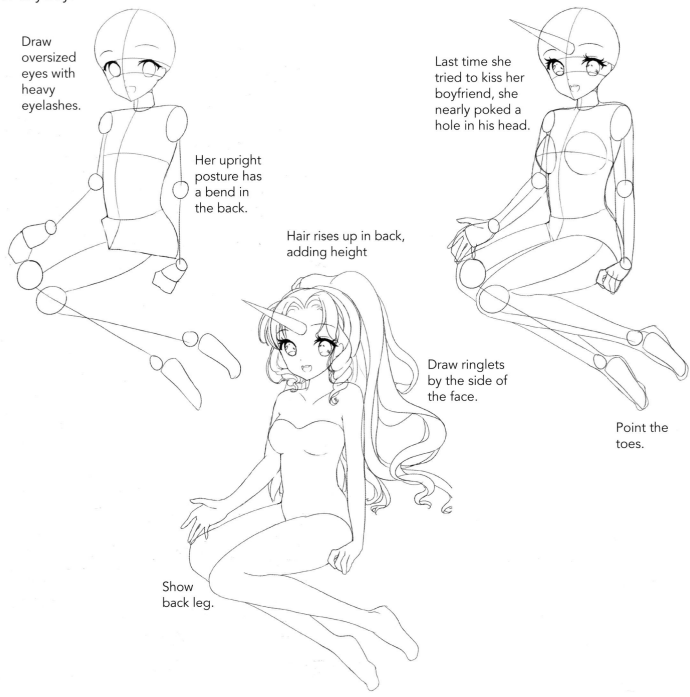

Draw oversized eyes with heavy eyelashes.

Her upright posture has a bend in the back.

Last time she tried to kiss her boyfriend, she nearly poked a hole in his head.

Hair rises up in back, adding height

Draw ringlets by the side of the face.

Point the toes.

Show back leg.

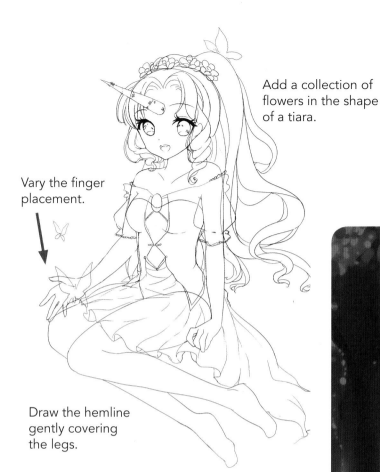

Add a collection of flowers in the shape of a tiara.

Vary the finger placement.

Draw the hemline gently covering the legs.

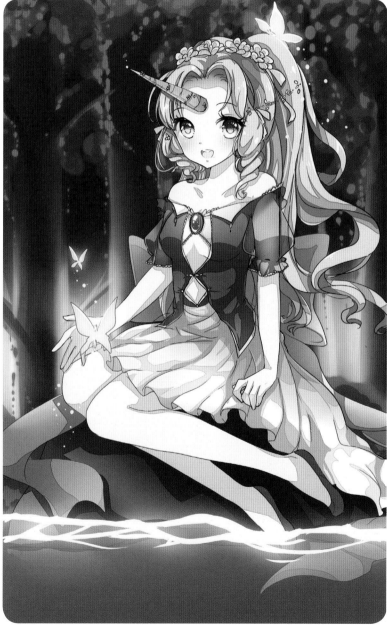

She looks very peaceful and serene. But if I were her, I'd be on the lookout for an angry horse that wants its horn back.

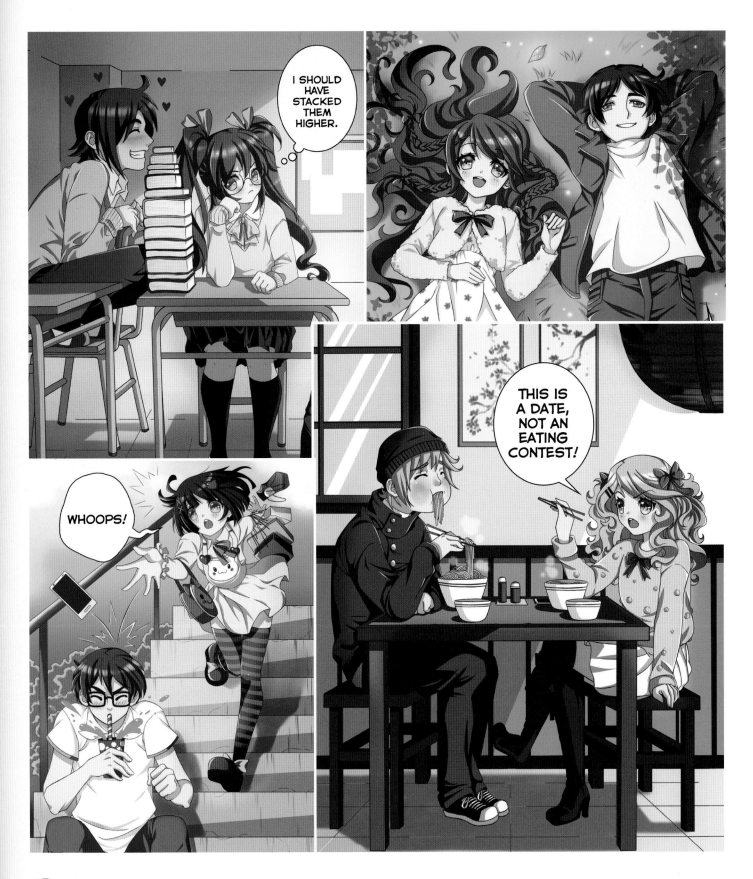

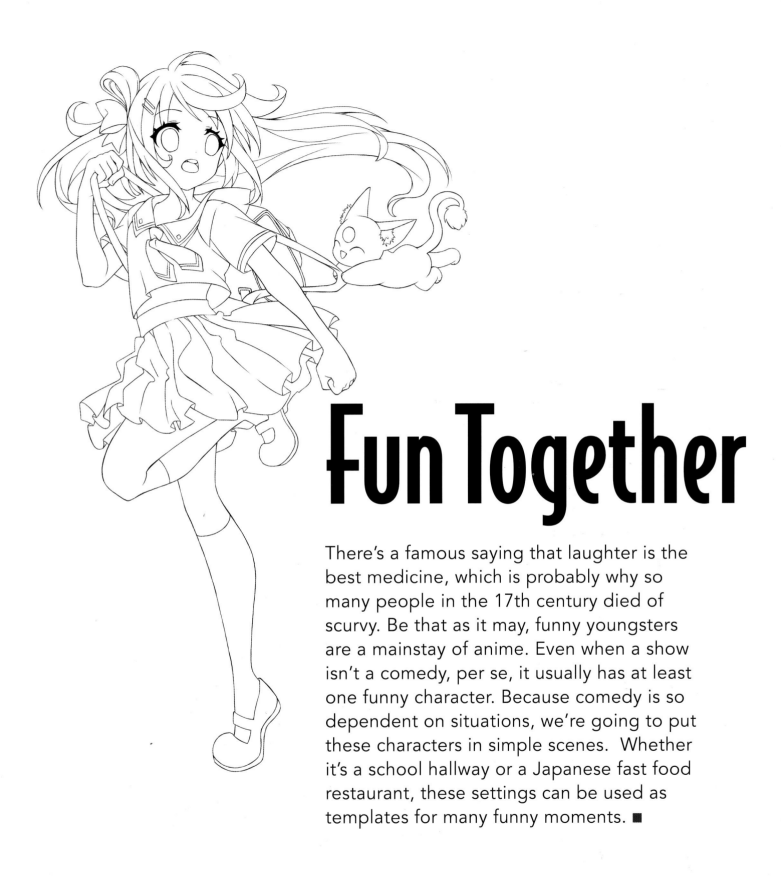

Fun Together

There's a famous saying that laughter is the best medicine, which is probably why so many people in the 17th century died of scurvy. Be that as it may, funny youngsters are a mainstay of anime. Even when a show isn't a comedy, per se, it usually has at least one funny character. Because comedy is so dependent on situations, we're going to put these characters in simple scenes. Whether it's a school hallway or a Japanese fast food restaurant, these settings can be used as templates for many funny moments. ■

Comedic Scenes

Each of the following comedic scenes feature anime characters in familiar locations. Comedy requires simplicity in setting up the scene. Too much detail overwhelms the humor.

GET ME OUT OF HERE!

Guy/girl stories provide great material for comedies. The intentions easily get mixed up, resulting in laughs. For example, in this image, the boy believes that the girl will like him if only he turns on the charm. But all she wants is for him to turn it "off."

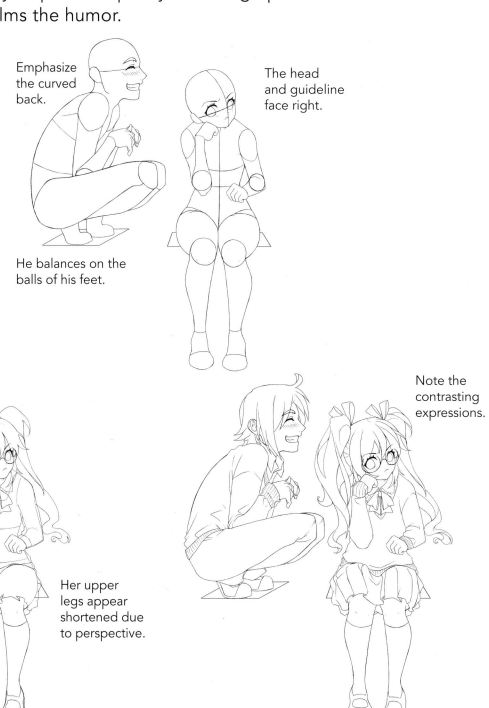

Emphasize the curved back.

He balances on the balls of his feet.

The head and guideline face right.

Note the contrasting expressions.

His knees are drawn slightly higher than his bottom.

Her upper legs appear shortened due to perspective.

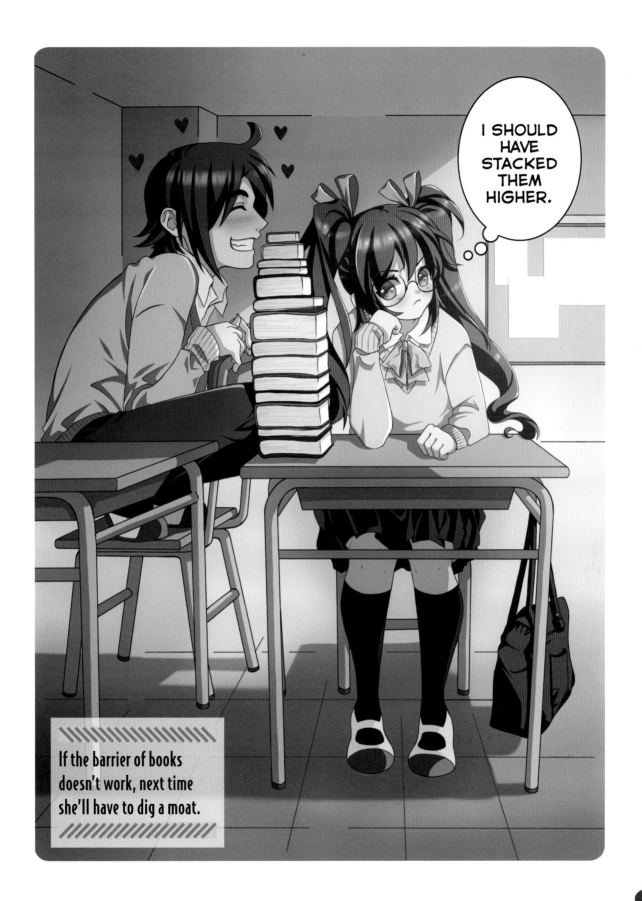

FIRST DATE

They met because of a mutual friend. That's one way to end a friendship. Having a meal at a table is a good way to set up a scene between two characters. Make use of the props, which include the food and chopsticks. And add contrast by drawing the boy and girl sitting in different positions.

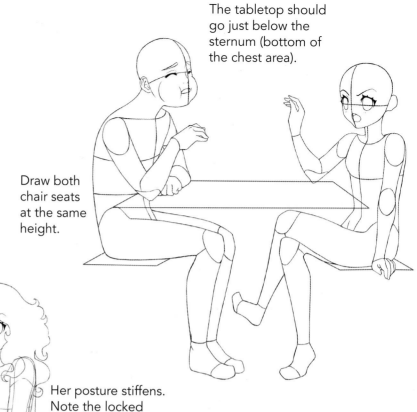

The tabletop should go just below the sternum (bottom of the chest area).

Draw both chair seats at the same height.

His posture is relaxed, with a rounded back.

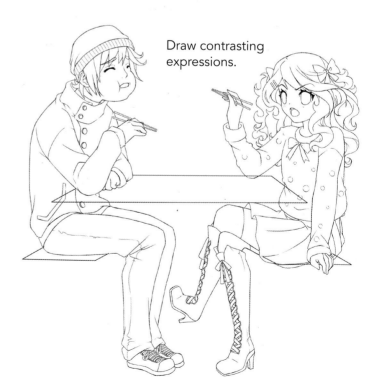

Her posture stiffens. Note the locked arm.

Draw contrasting expressions.

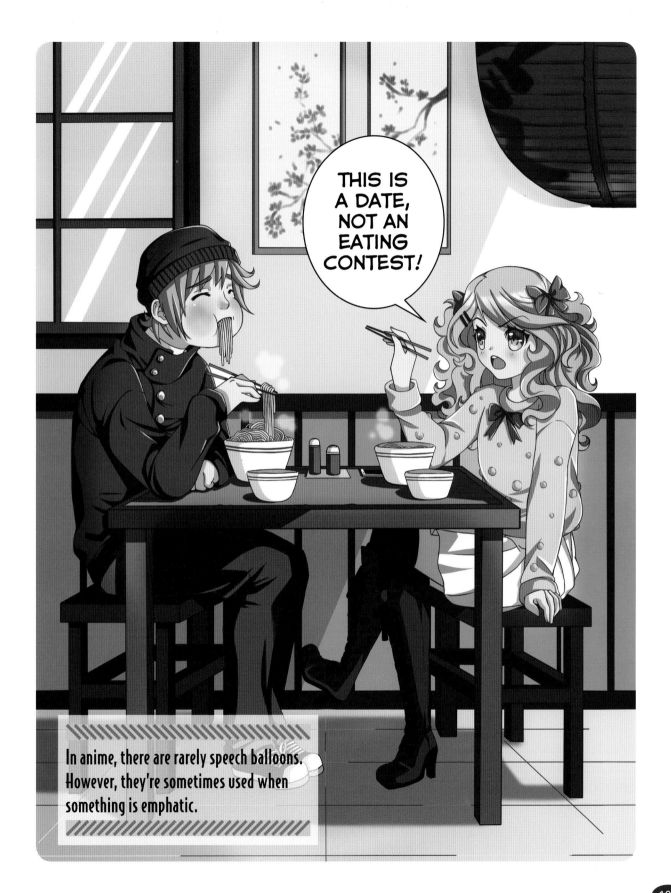

THIS IS A DATE, NOT AN EATING CONTEST!

In anime, there are rarely speech balloons. However, they're sometimes used when something is emphatic.

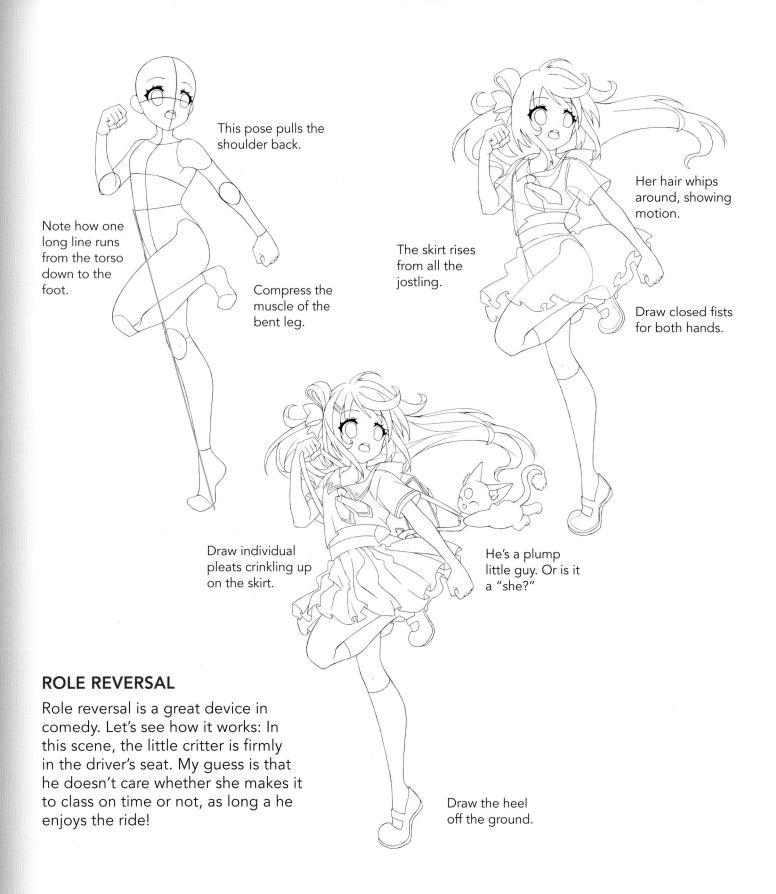

This pose pulls the shoulder back.

Note how one long line runs from the torso down to the foot.

Compress the muscle of the bent leg.

Her hair whips around, showing motion.

The skirt rises from all the jostling.

Draw closed fists for both hands.

Draw individual pleats crinkling up on the skirt.

He's a plump little guy. Or is it a "she?"

ROLE REVERSAL

Role reversal is a great device in comedy. Let's see how it works: In this scene, the little critter is firmly in the driver's seat. My guess is that he doesn't care whether she makes it to class on time or not, as long a he enjoys the ride!

Draw the heel off the ground.

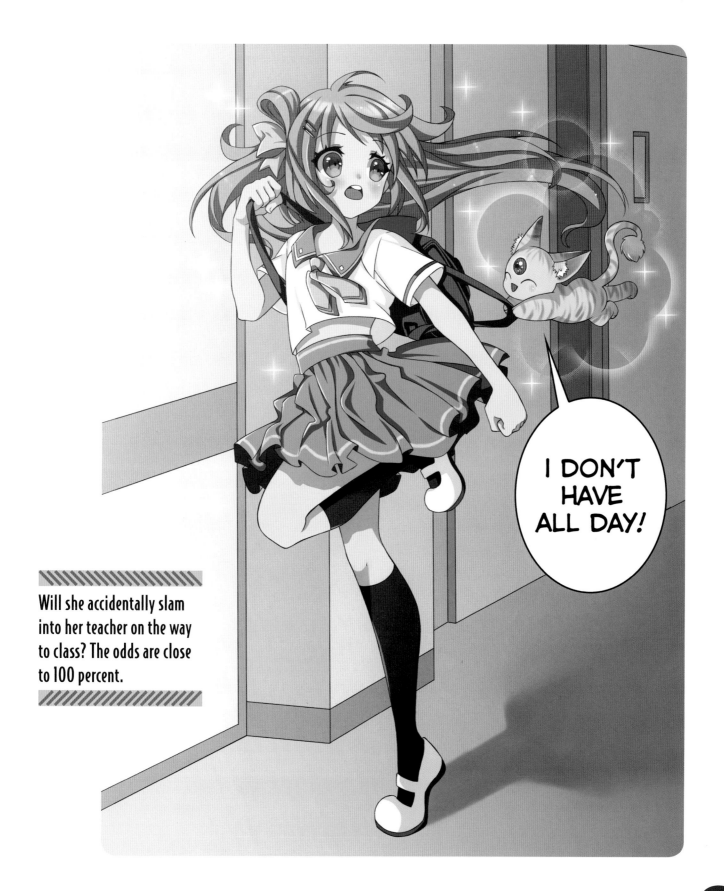

Will she accidentally slam into her teacher on the way to class? The odds are close to 100 percent.

I DON'T HAVE ALL DAY!

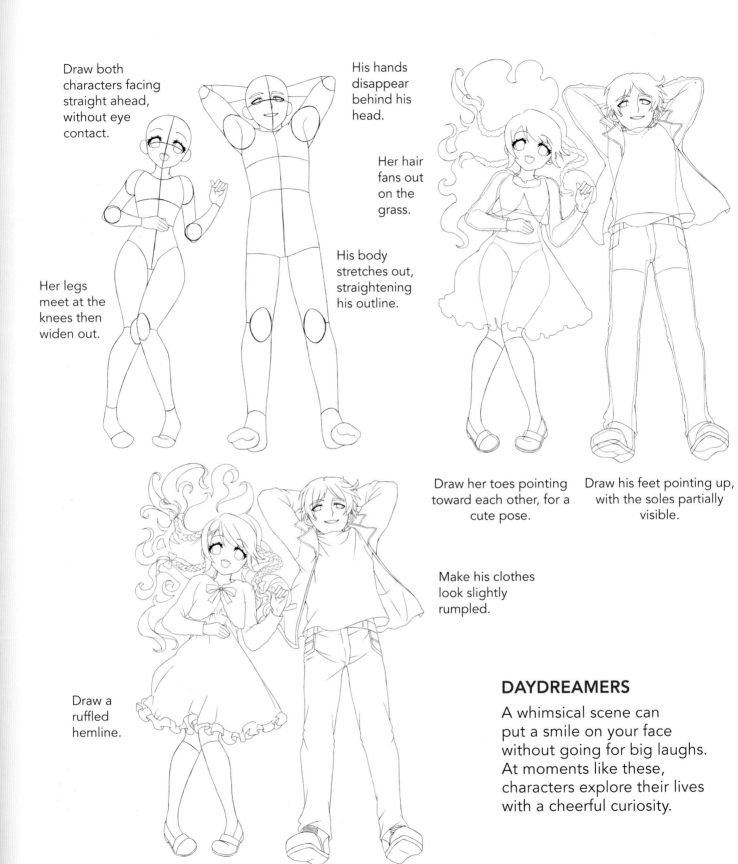

Draw both characters facing straight ahead, without eye contact.

His hands disappear behind his head.

Her hair fans out on the grass.

His body stretches out, straightening his outline.

Her legs meet at the knees then widen out.

Draw her toes pointing toward each other, for a cute pose.

Draw his feet pointing up, with the soles partially visible.

Make his clothes look slightly rumpled.

Draw a ruffled hemline.

DAYDREAMERS

A whimsical scene can put a smile on your face without going for big laughs. At moments like these, characters explore their lives with a cheerful curiosity.

Here, our couple is involved in a deep, existential conversation, which will momentarily be interrupted by the boy's comment, "Want to get pizza?" The mystery of life, thrown under the bus for a slice of pepperoni.

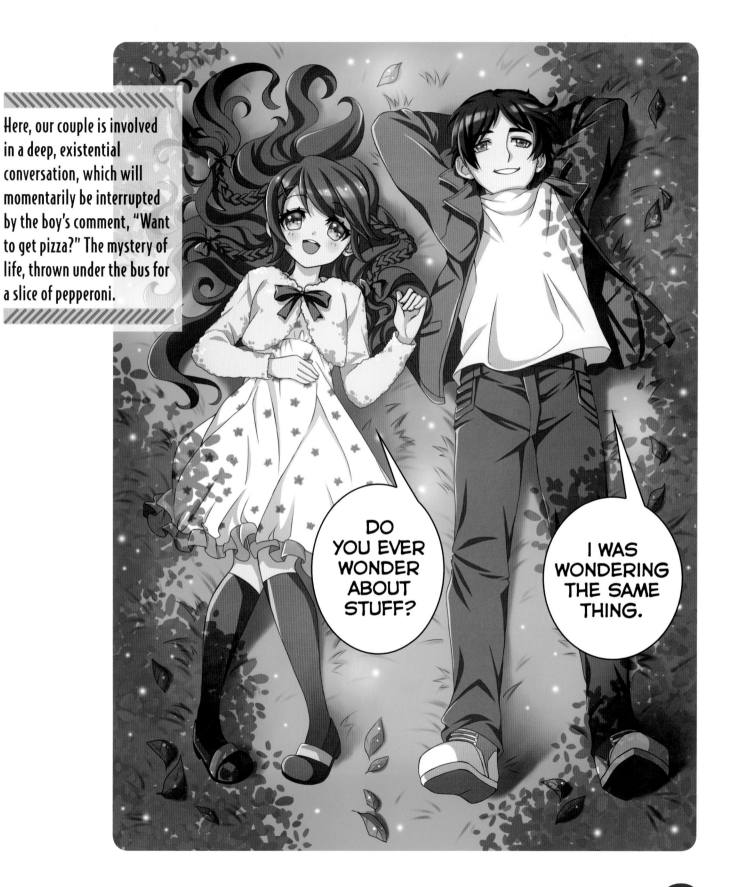

THE "KLUTZ" MOMENT

This comedy star of anime requires an accidental victim. The klutz may promise to be careful *this time*. And she'll mean it. And if you believe her, that's on you.

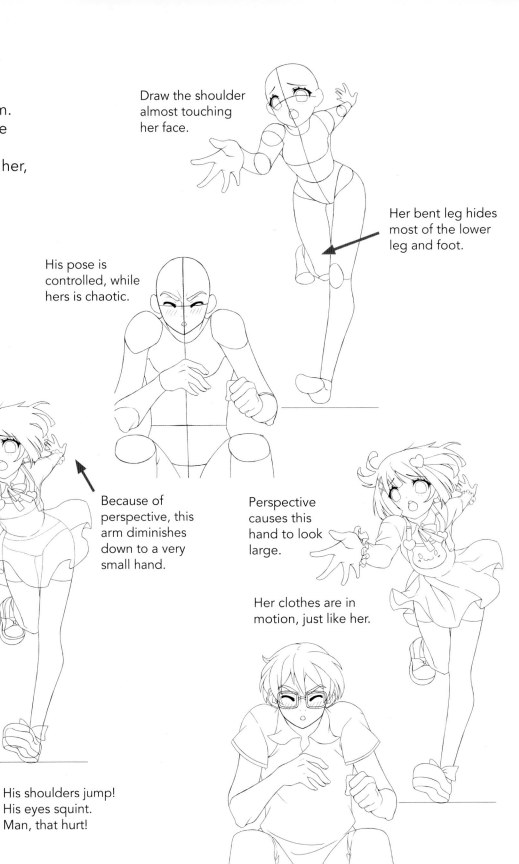

Draw the shoulder almost touching her face.

Her bent leg hides most of the lower leg and foot.

His pose is controlled, while hers is chaotic.

Because of perspective, this arm diminishes down to a very small hand.

Perspective causes this hand to look large.

Her clothes are in motion, just like her.

His shoulders jump! His eyes squint. Man, that hurt!

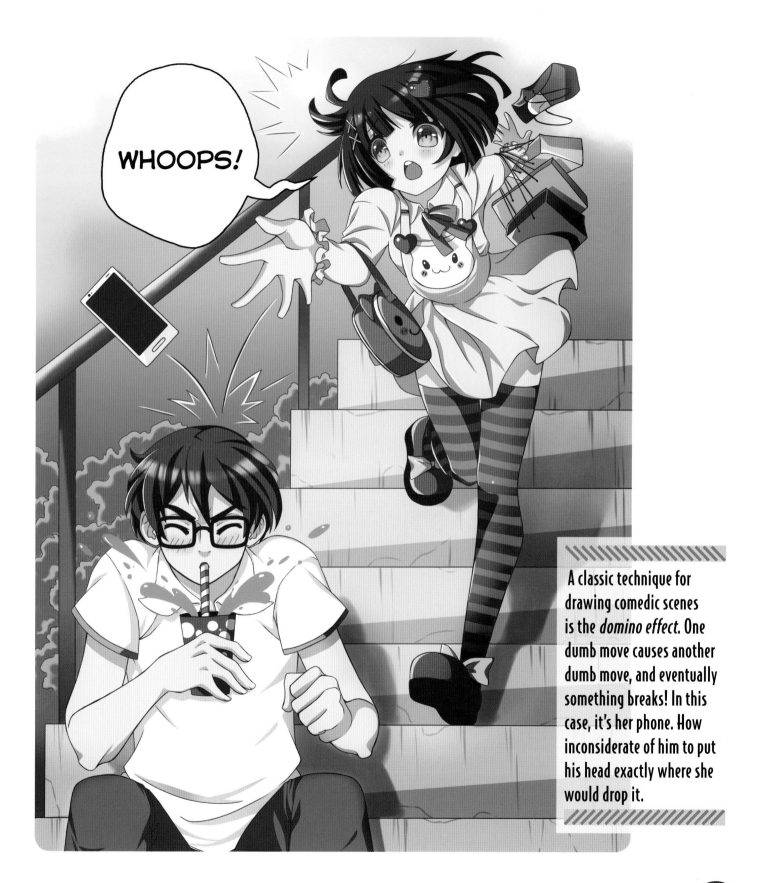

A classic technique for drawing comedic scenes is the *domino effect*. One dumb move causes another dumb move, and eventually something breaks! In this case, it's her phone. How inconsiderate of him to put his head exactly where she would drop it.

UNINVITED GUESTS

In the psychological genre, characters are thrust into suspenseful situations where they must use their wits to save themselves. The genre also features mysterious creatures that lurk about. Think of them as hall monitors from another dimension. Although the key to this category is the element of danger, a ghost made out of a pillow gives it a comedic angle.

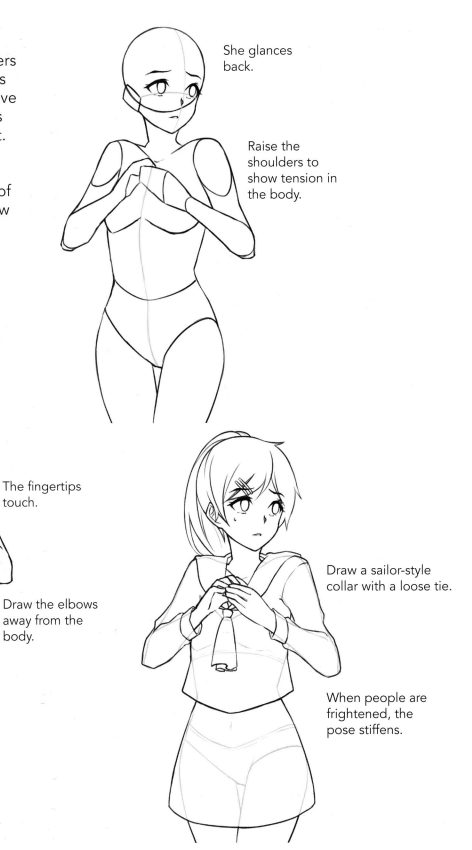

She glances back.

Raise the shoulders to show tension in the body.

Draw the ponytail on the left side.

The fingertips touch.

Draw the elbows away from the body.

Draw a sailor-style collar with a loose tie.

When people are frightened, the pose stiffens.

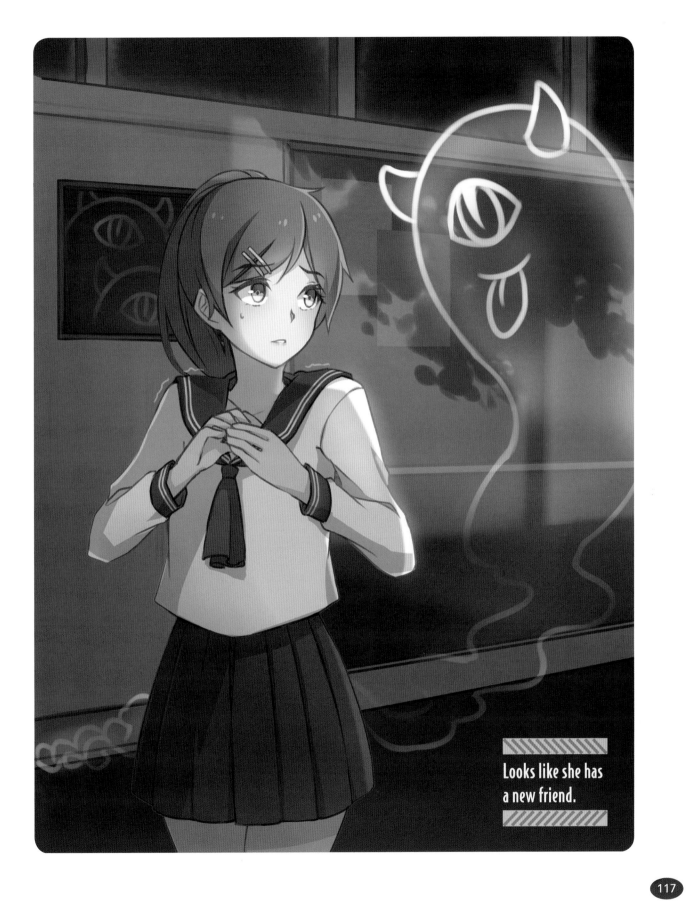

Romance

Many aspiring artists want to draw romantic scenes but aren't sure what to draw. This chapter will give you the popular character types, staged in compelling situations, and the techniques you need to draw them. ■

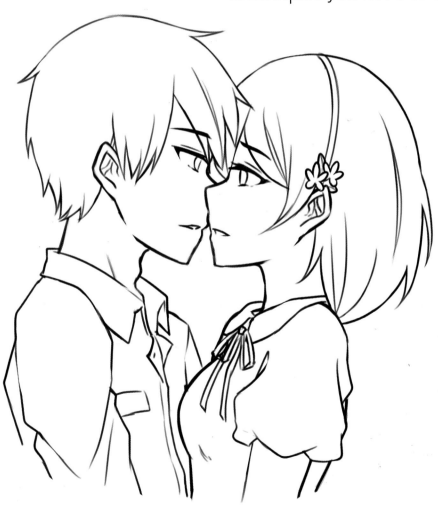

Romantic Scenes

The key to the romance genre is to draw an image that describes the relationship in a nutshell. Maybe it's that instant when two teens fall in love, or when they break up. Allow the story to unfold via the illustration.

ENDLESS POSSIBILITIES

In this scene, our couple is watching shooting stars traverse the night sky. The guy points out the biggest one, which is a civilization-ending asteroid headed directly toward the earth. Quick—take a selfie!

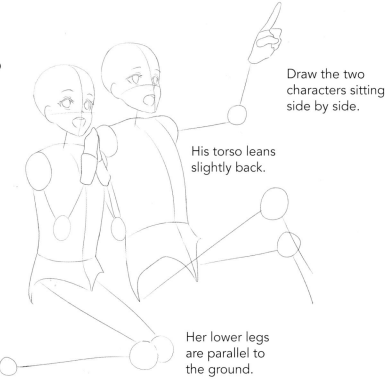

Draw the two characters sitting side by side.

His torso leans slightly back.

Her lower legs are parallel to the ground.

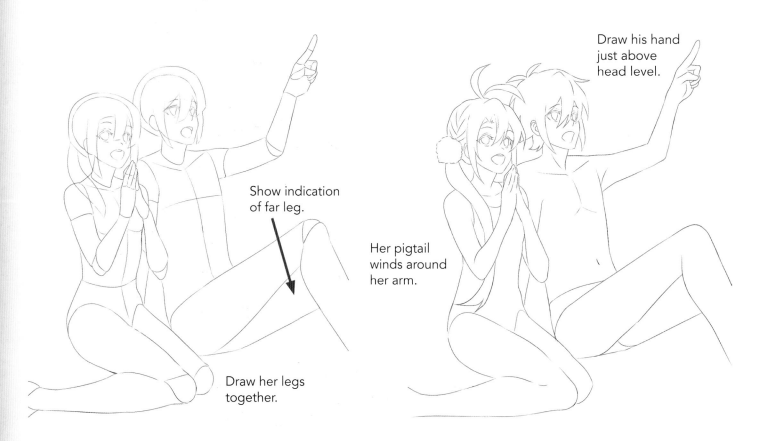

Show indication of far leg.

Draw her legs together.

Her pigtail winds around her arm.

Draw his hand just above head level.

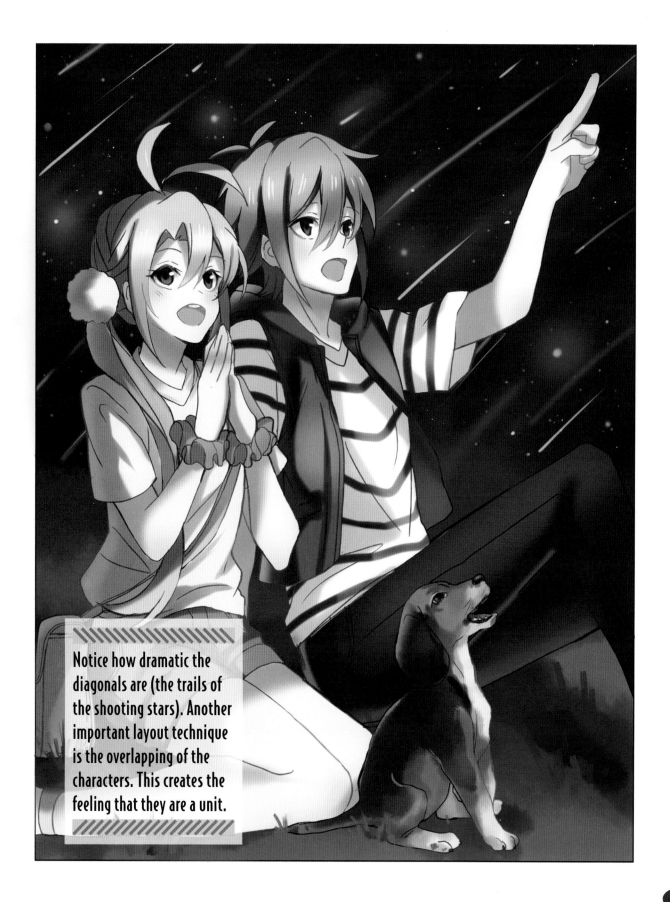

Notice how dramatic the diagonals are (the trails of the shooting stars). Another important layout technique is the overlapping of the characters. This creates the feeling that they are a unit.

ROMANTIC COMEDY

Is romantic comedy primarily romance or primarily comedy? The answer is: both! The story frequently alternates between hilarious moments and tender moments. For example, in this picture, the boy stopped a girl to ask for directions to the soccer field. And she's going to take him there, right after she takes him home to meet her parents.

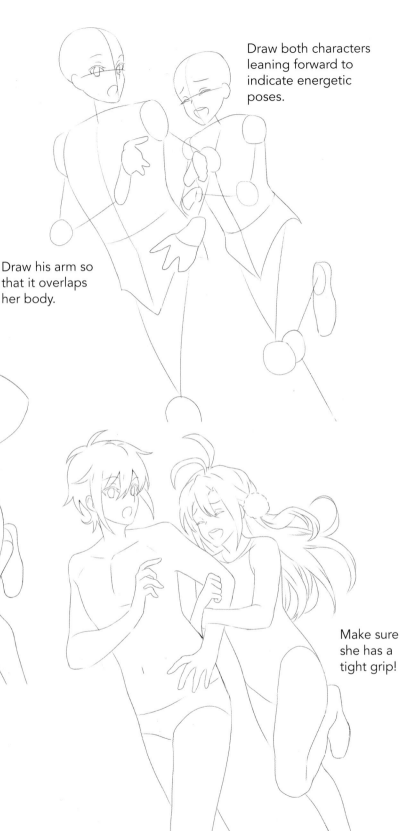

Draw both characters leaning forward to indicate energetic poses.

Draw his arm so that it overlaps her body.

Draw the fingers of his hands spread apart in random positions, which indicates surprise.

Her thigh hides part of her lower leg.

Make sure she has a tight grip!

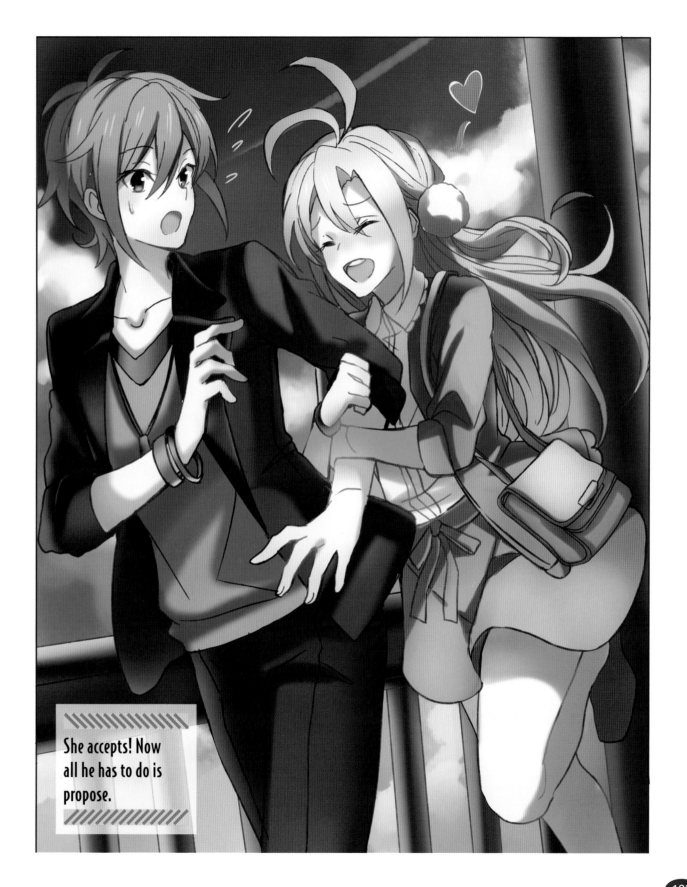

She accepts! Now all he has to do is propose.

ANTICIPATION

Anticipation is like trying to keep two magnets separated. A force, in this case love, will pull them back together. Also, they'll be covered in paperclips. This couple's parents may try to separate them. But the young lovers will find a way to see each other. Eventually, of course, they will return to their parents—to borrow money and use the car.

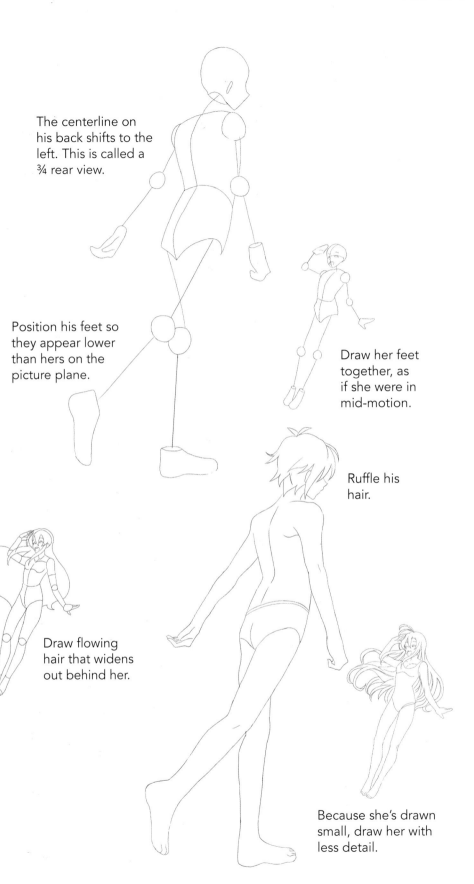

The centerline on his back shifts to the left. This is called a ¾ rear view.

Position his feet so they appear lower than hers on the picture plane.

Draw her feet together, as if she were in mid-motion.

Extend his leg back.

Draw flowing hair that widens out behind her.

Ruffle his hair.

Because she's drawn small, draw her with less detail.

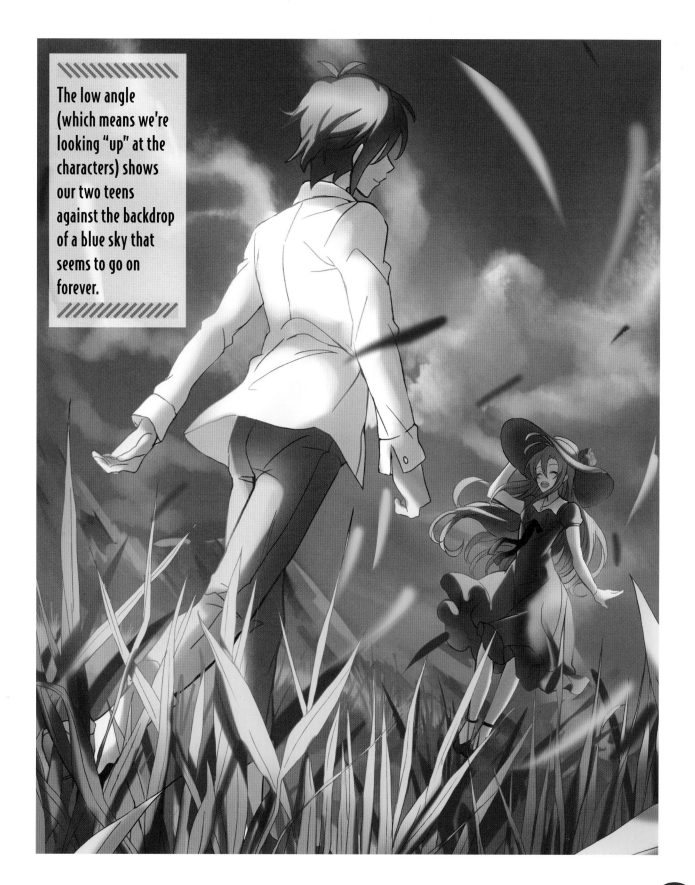

The low angle (which means we're looking "up" at the characters) shows our two teens against the backdrop of a blue sky that seems to go on forever.

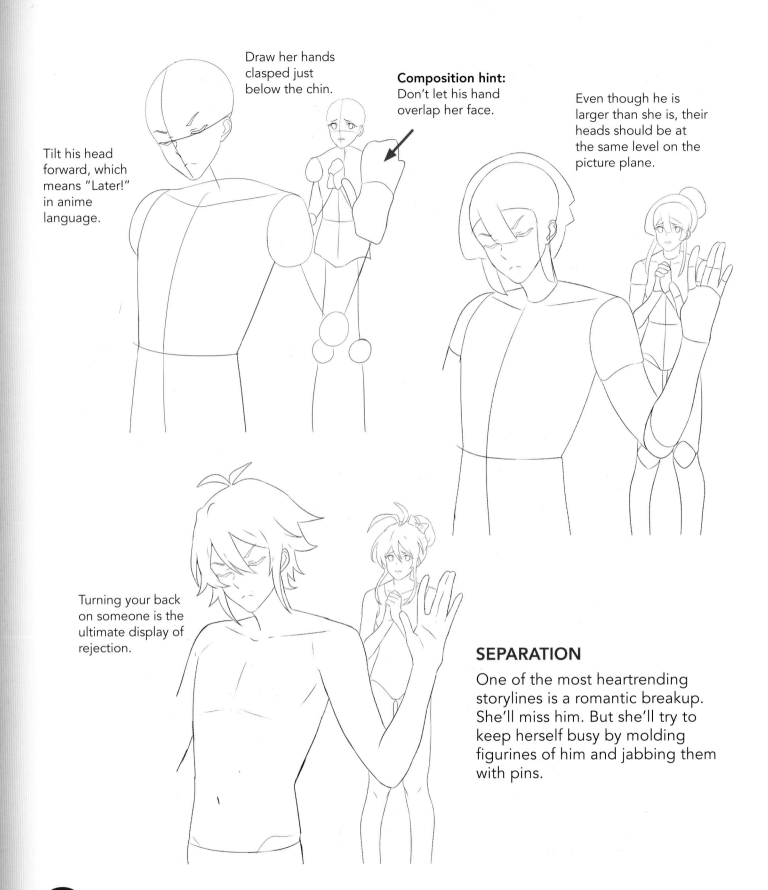

Draw her hands clasped just below the chin.

Composition hint: Don't let his hand overlap her face.

Even though he is larger than she is, their heads should be at the same level on the picture plane.

Tilt his head forward, which means "Later!" in anime language.

Turning your back on someone is the ultimate display of rejection.

SEPARATION

One of the most heartrending storylines is a romantic breakup. She'll miss him. But she'll try to keep herself busy by molding figurines of him and jabbing them with pins.

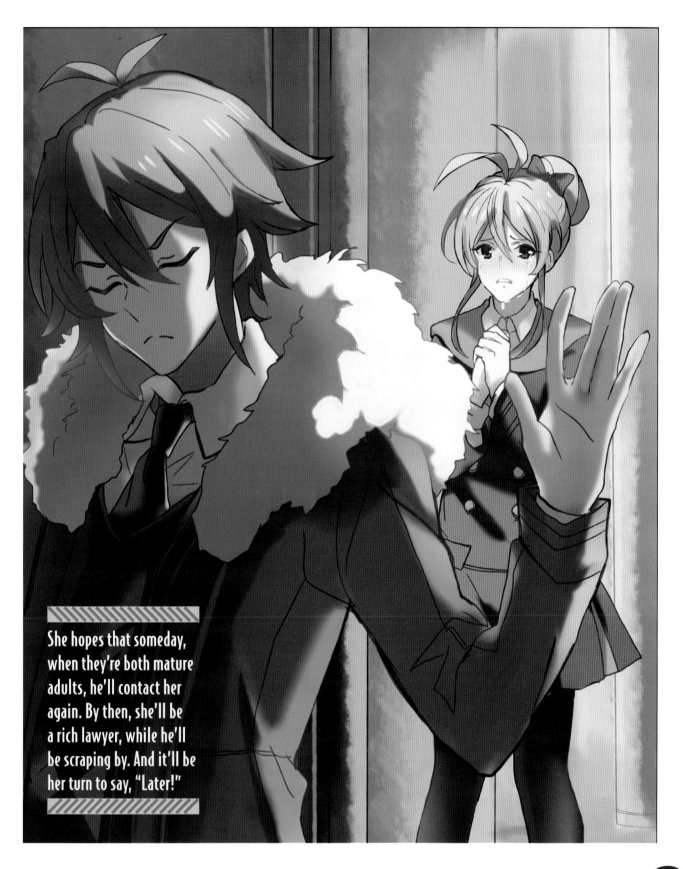

She hopes that someday, when they're both mature adults, he'll contact her again. By then, she'll be a rich lawyer, while he'll be scraping by. And it'll be her turn to say, "Later!"

Drawing Important Moments

The best drawings are about something. They capture a character, or characters, in important moments. In this section, you'll get the steps to drawing romantic characters in key moments that grab the audience's attention.

ALMOST A KISS

Characters in love are often cautious. That's because of the obstacles that have been put in the way of their romance. Those obstacles could be parents, an ex, or obligations. Adding such impediments creates depth.

Overlap the noses.

Keep the overall shape of the faces simple.

If their lips can get closer than this without kissing, I don't know how.

Eyes locked

Notice that their arms are still at their sides, as they struggle to resist.

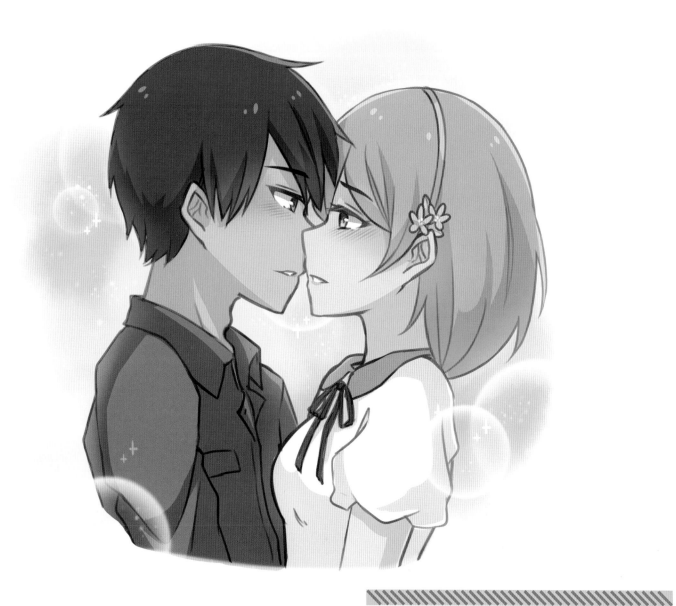

The most important part of this scene is the moment *before* the moment. In other words, it's the tension that grabs the audience's interest. Will they kiss or won't they? What do you think? (I think so, too.)

UNINTENDED CONSEQUENCES

Broad romantic humor requires characters that can react quickly with engaging expressions. In these situations, the rule is this: Anything that can go wrong will. And the gags keep escalating. It's as if there were a mischievous gremlin writing the story, with the characters at his mercy!

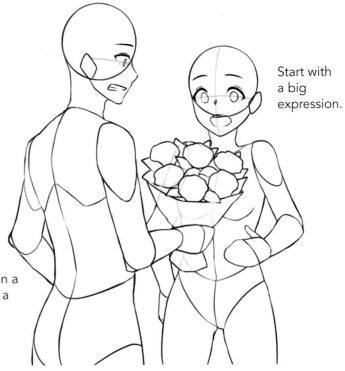

Start with a big expression.

Draw his back in a ¾ view. It's not a pure profile.

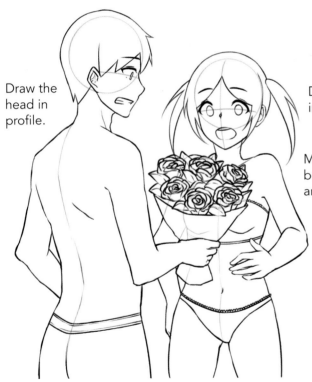

Draw the head in profile.

Draw her head in a front view.

Maintain a space between the roses and her chin.

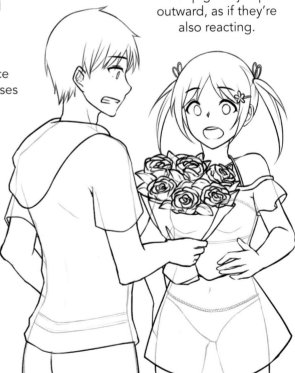

Her pigtails jump outward, as if they're also reacting.

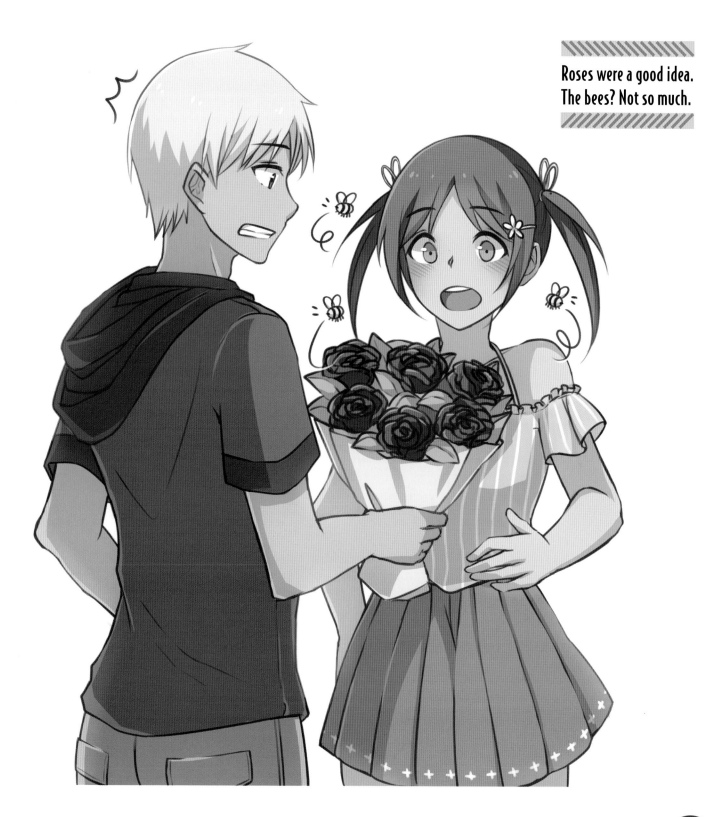

Roses were a good idea.
The bees? Not so much.

131

EPIC FAIL

Our intrepid skier was teaching his girlfriend how to ski. First, he taught her how to fall, then how to roll down the mountain, and finally, how to face-plant into a mound of snow.

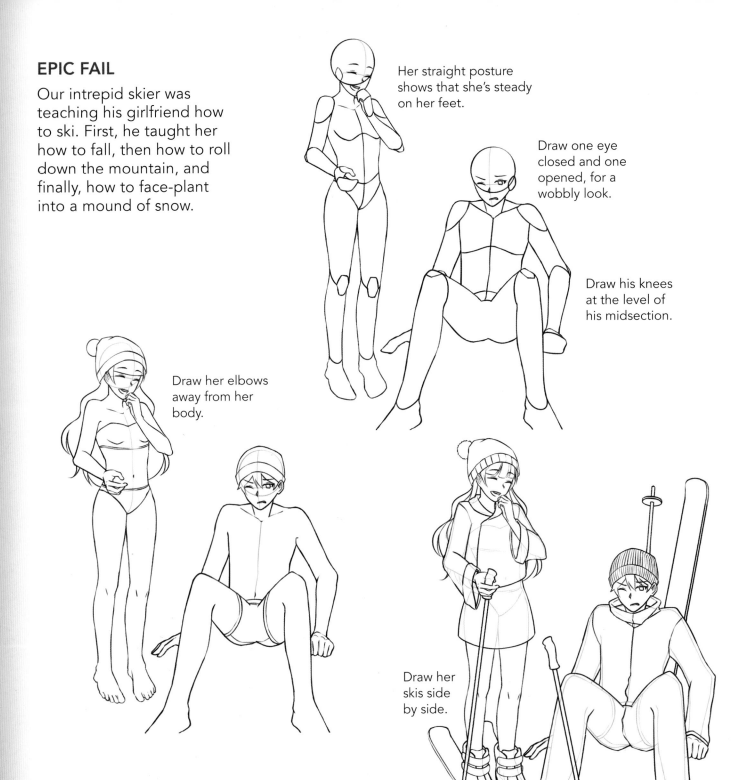

Her straight posture shows that she's steady on her feet.

Draw one eye closed and one opened, for a wobbly look.

Draw his knees at the level of his midsection.

Draw her elbows away from her body.

Draw her skis side by side.

He's not even sure where his skis are!

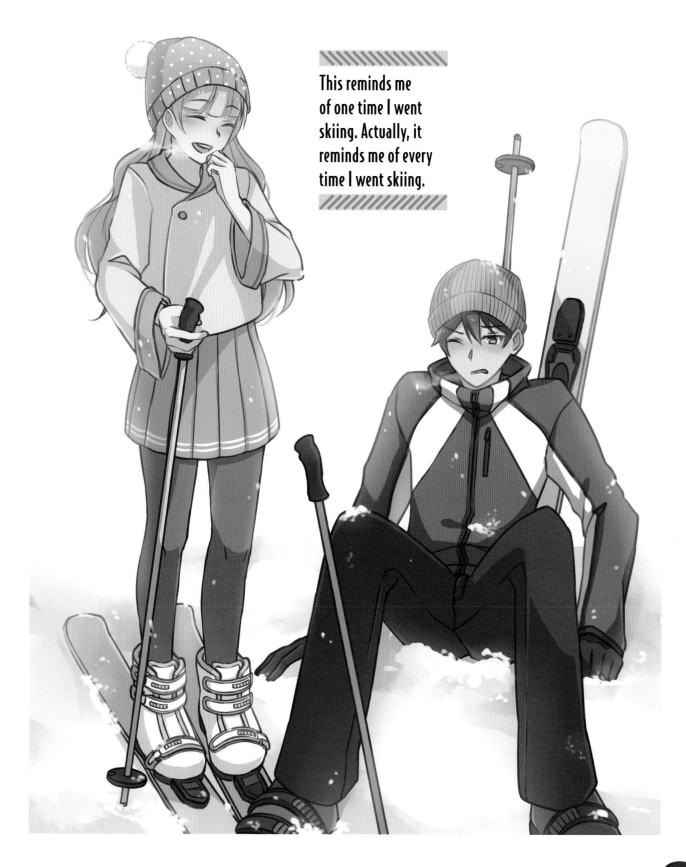

This reminds me of one time I went skiing. Actually, it reminds me of every time I went skiing.

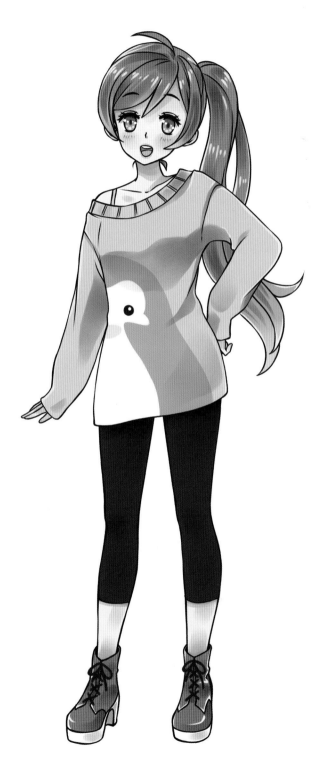

More Tips and Tricks

In this final chapter, we'll fine tune what we've covered so far with a few extra techniques and helpful hints that can really take your anime creations to the next level. You'll learn how to develop the details of a character from all angles, so you can be sure it looks consistent in every frame. We'll also go over how to correctly place multiple characters within a scene and how to draw eye-catching backgrounds that help to deepen the context of a story. From there, you can start to play with drawing your own original anime creations. The sky's the limit! ∎

Getting to Know Your Character

Many aspiring artists want to draw their own character at different angles without it losing its look. The best way to get there is by creating something called a *model sheet*. A model sheet is comprised of drawings that highlight different aspects of a character, including gestures, expressions, clothes, and colors. Creating one forces you to become familiar with all aspects of your character.

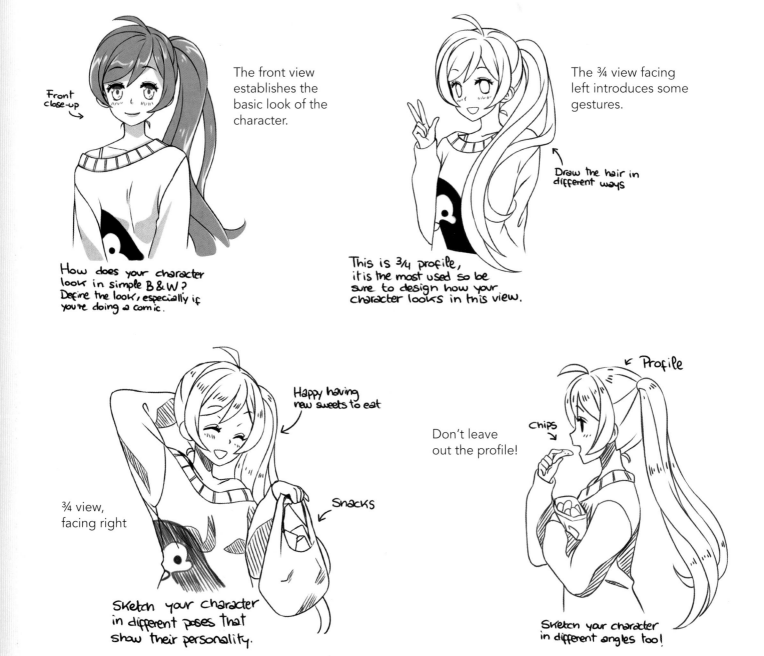

Front close-up

The front view establishes the basic look of the character.

How does your character look in simple B & W? Define the look, especially if you're doing a comic.

The ¾ view facing left introduces some gestures.

Draw the hair in different ways

This is ¾ profile, it is the most used so be sure to design how your character looks in this view.

¾ view, facing right

Happy having new sweets to eat

Snacks

Sketch your character in different poses that show their personality.

Don't leave out the profile!

Profile

Chips

Sketch your character in different angles too!

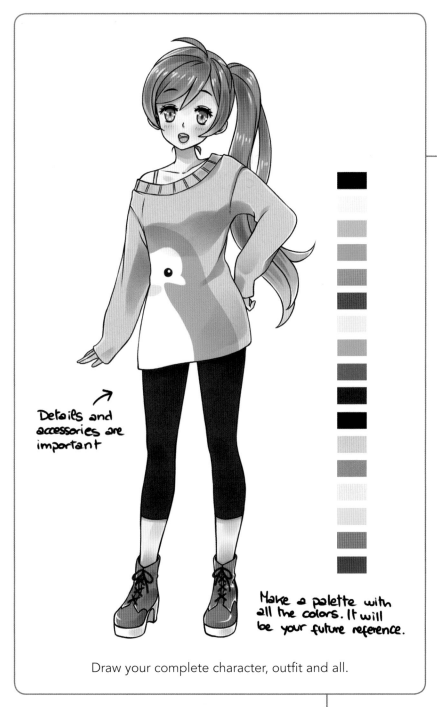

Details and accessories are important

Make a palette with all the colors. It will be your future reference.

Draw your complete character, outfit and all.

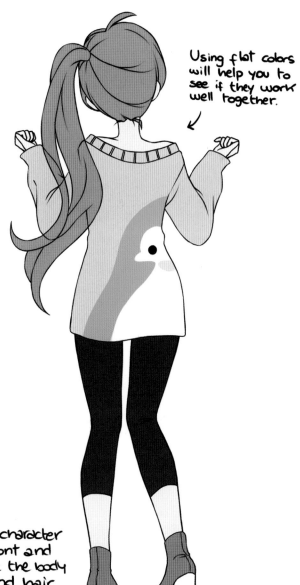

A back view allows you to show the "wraparound" look of the pattern.

Using flat colors will help you to see if they work well together.

Draw your character full body front and back to see the body proportion and hair and outfit details.

Drawing Three Or More Characters in a Scene

The Circle of Friends scene is famous in anime. It's where a group of characters gets together to have fun. Draw the cast members from different angles, and vary their heights, clothes, hairstyles, and gestures.

To start, rough out the angles at which the three characters are standing:

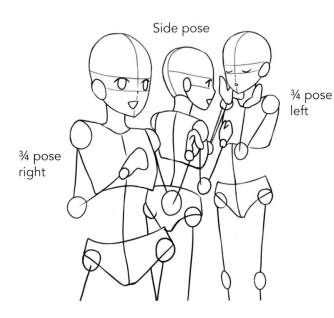

Side pose

¾ pose left

¾ pose right

The layout emphasizes the first and third characters. The one in the middle is less important and is used for pacing, which is why she's facing away from us.

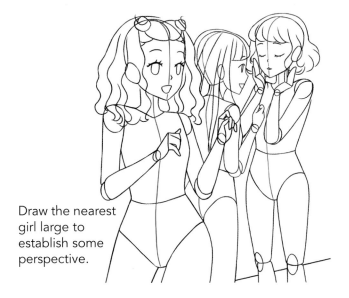

Draw the nearest girl large to establish some perspective.

The near character overlaps the middle character.

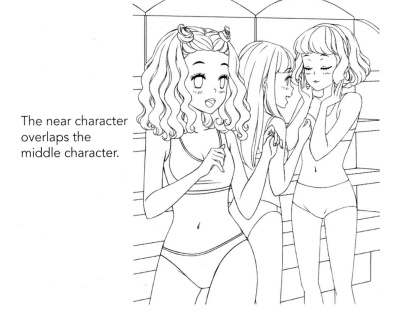

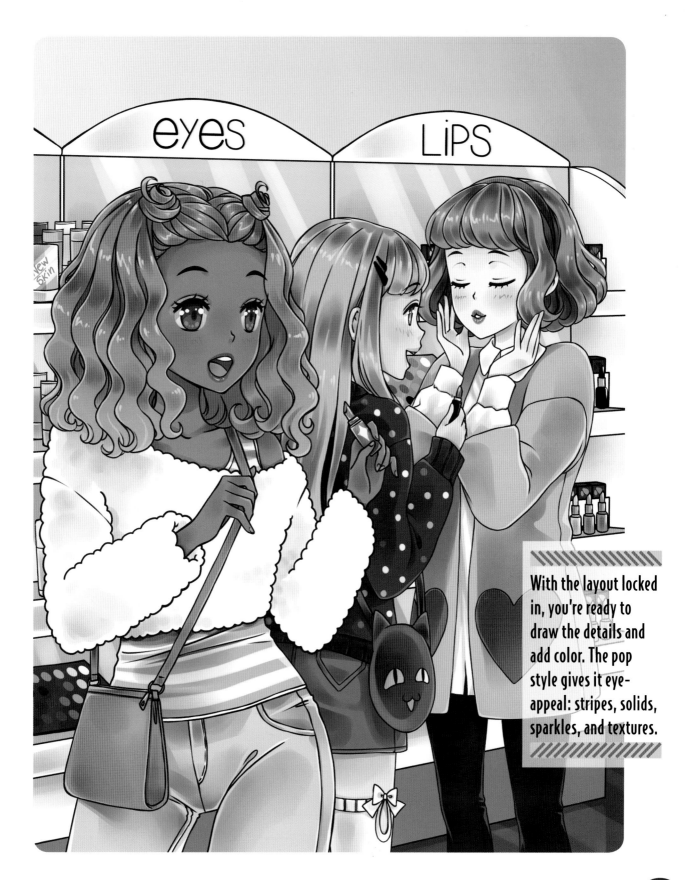

With the layout locked in, you're ready to draw the details and add color. The pop style gives it eye-appeal: stripes, solids, sparkles, and textures.

Background Suggestions

We'll finish up this chapter by examining backgrounds more closely. Some artists prefer to draw a character first and the background second. Others like to start with the background and position the characters within it. My suggestion is to lightly sketch out the character and scene together, alternating between the two. It helps to adjust the drawing as you go.

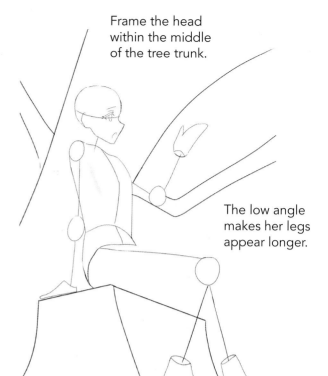

Frame the head within the middle of the tree trunk.

The low angle makes her legs appear longer.

CHERRY BLOSSOMS

Cherry blossoms are everywhere in anime. They create a beautiful setting. The leaves gently detach from the branches at the first breeze, filling the scene with color and charm.

Thumb side up

Draw the short side of the bench at a down angle to the left.

Draw the long side of the bench down and to the right.

The branches fork off as they extend outward.

Indent the waistline.

Show far leg.

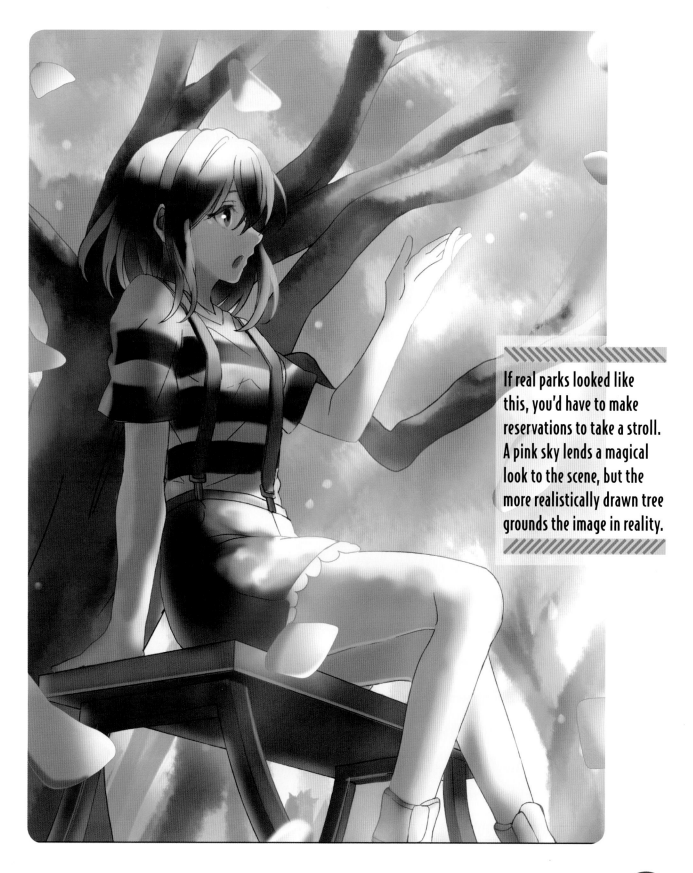

If real parks looked like this, you'd have to make reservations to take a stroll. A pink sky lends a magical look to the scene, but the more realistically drawn tree grounds the image in reality.

CITY PARK

This is a must-draw setting for your anime characters. I'm sure you've seen it used in many shows. The setting shows a path lined by plenty of trees. In order to show that it's a park and not the country, draw a hint of a high-rise building at the top of the image.

Draw the head and figure in a ¾ view, turned toward the right.

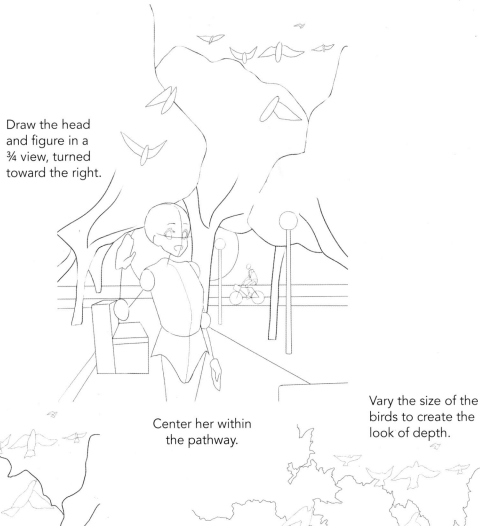

Create irregular shapes for the leafy treetops.

Center her within the pathway.

Vary the size of the birds to create the look of depth.

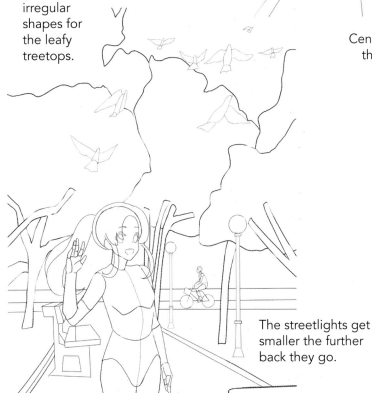

The streetlights get smaller the further back they go.

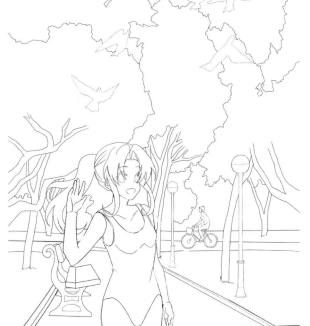